LOST
KILMARNOCK

FRANK BEATTIE

AMBERLEY

*I completed work on this book on 14 June 2023. On the same day,
my granddaughter, Anna Elisabeth Castelli Beattie, was born. This book is dedicated to her.
May she learn from the past to build a better future.*

Frank Beattie

*With thanks to Sandy Armour, Graham Boyd, Frank Spence, The Burns Monument Centre,
and The Kilmarnock Picture house.*

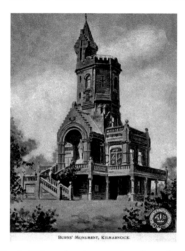

The Burns Monument in the Kay Park before the devastating fire of 2004.

First published 2024

Amberley Publishing
The Hill, Stroud
Gloucestershire, GL5 4EP

www.amberley-books.com

British Library Cataloguing in Publication Data.

A catalogue record for this book is available from the British Library.

ISBN 978 1 3981 1823 2 (print)
ISBN 978 1 3981 1824 9 (ebook)

Origination by Amberley Publishing.
Printed in the UK.

Contents

Introduction

No one can be sure just when Kilmarnock was founded. The name suggests that it was in the Christian era; Kilmarnock translates into 'The Church dedicated to St Marnock'. That does not answer the essential questions. Was a church attracted to an existing community or did a community grow around an isolated church? Also, why is Kilmarnock where it is?

There was an important Roman fort at Loudoun Hill. They had settlements at what would become Ayr, Irvine and Glasgow. Roads linked them and a road from Ayr to Glasgow and one from Loudoun Hill to Irvine cross at just where Kilmarnock is now. Did Kilmarnock start at an ancient crossroads? Maybe.

But even in the fourth and fifth centuries there is still no evidence for anything approaching a significant community in Kilmarnock.

The theory goes that having been established, the church started to attract a few followers who built their homes near the church that they were devoted to. But there was no industry yet; no community. Kilmarnock must have remained as little more than a cluster of huts, probably for a few more hundred years.

However, by the start of the second millennium it had not just a church. It had a name as well.

Archibald McKay's *History of Kilmarnock* (1848) says that Saint Marnock founded his church here at the end of the sixth or start of the seventh century and that he was buried in the area. Other writers say that the church was simply dedicated to the memory of St Marnock.

The earliest mention of Kilmarnock in literature is in Barbour's *Life of Bruce*. Kilmarnock is noted as one of the places through which an English knight, Sir Philip de Mowbray, retreated after his defeat in 1306. The fourteenth and fifteenth centuries were noted for the construction of strong stone castles, and yet, the little church by the river, the one dedicated to Saint Marnock, remained in its rural setting, surrounded by a few huts and, perhaps, farms or crofts.

In 1547 a new parish priest came to Kilmarnock. Significantly, he was elected, or at least approved, by the town's people. The document that tells of this suggests that there were some 300 families living in the parish, a population of, perhaps, around 1,400. Kilmarnock was still a rural community. But there was thriving commerce, for in 1591 Kilmarnock was made a Burgh of Barony, which allowed the merchants various rights.

The first significant view of early Kilmarnock comes from Timothy Pont, who visited the town early in the seventeenth century, probably in 1609. He described Kilmarnock as being a large village in great repair. He said the people held a weekly market. He mentioned the bridge which at that time was at the Sandbed Brig, saying that it was a 'faire stone bridge', and he described the church as being 'pretty'.

A generation later, in 1657 another visitor came to Kilmarnock and recorded what he saw. He was Richard Franck, who apparently came to Scotland on a fishing tour.

In this remarkable volume he said that Kilmarnock was an ancient corporation, crowded with mechanics and brewhouses. He described the streets as 'crazy, tottering ports'. The streets

were dirty, except when heavy rain washed the muck into the river. He said that there was bonnet making and weaving but he highlighted the metal workers which he said were the best in Scotland. Perhaps the skills of the men of those days were passed on to later generations who became the engineers who established the great industries of the town in the nineteenth century.

Kilmarnock remained little more than a large village until the start of the nineteenth century. Coal was important at this time and coal mined in the Kilmarnock area was shipped to Ireland, but it had to be taken to Irvine on pack horses. Then a new landowner came on the scene. He was William Henry Cavendish Bentinck, and he drew up a five-point plan. He wanted to revitalise the coal industry, reshape Kilmarnock town centre, build a canal to take coal to a new harbour at Troon and he wanted to build a new town at Troon. The canal plan was later dropped in favour of a railway.

The Kilmarnock and Troon Railway changed everything. It opened in the summer of 1812, with a time-tabled passenger service and it not only took coal and other goods to Troon for export, it brought in many goods. Kilmarnock started to grow rapidly.

By the middle of the nineteenth century Kilmarnock was a centre of engineering, a town that produced shoes, carpets, whisky and was a centre of agricultural produce, particularly cheese.

By the dawn of the twentieth century companies founded in Kilmarnock were exporting goods all over the world. They included locomotives, made by Barclays; boots and shoes made by Saxone; carpets by BMK; water fountains and valves made by Glenfield and Kennedy; and of course, whisky, made by Johnnie Walker.

After the First World War, there was a demand for 'Homes fit for heroes' and some of the first schemes of council housing date from the early 1920s. It was another period of rapid expansion for the town. After the Second World War, there was another demand for better housing and new businesses such as Glacier Metal and Massey Harris, later Massey Ferguson, settled in Kilmarnock.

In the 1970s Kilmarnock saw a period of rapid change. Much of the old town centre, including Duke Street, Fore Street, Regent Street, Waterloo Street and others in the commercial heart of the town, was swept away in favour of a shopping centre that has as much architectural appeal as a shoebox. Many residential streets were also cleared to make way for better and more spacious homes.

By the 1980s and 1990s the world economy was turning global and few of Kilmarnock's major industries survived. With better transport links Kilmarnock began to look like a dormitory town for Glasgow.

In the twenty-first century people began using technology to shop from home. In common with so many other towns, these trends saw a decline of traditional town centres.

Change is inevitable. The new comes in and the old is swept away. Sometimes replacing the old is good, but it is often regretted by many.

In this book, let's take a look at some of the streets, buildings and industries that together tell of a Lost Kilmarnock.

I

Lost Streets

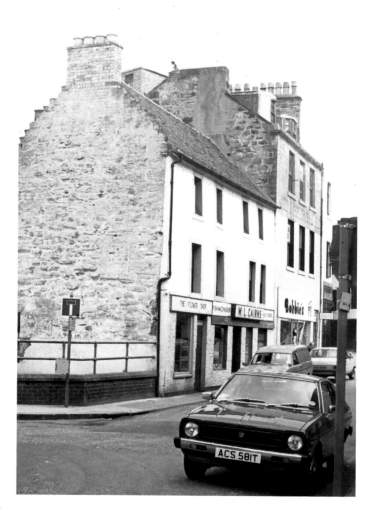

Cheapside Street

The line of Cheapside, or Cheapside Street, still exists today. It was first built around 1550 or before. It is likely to have originally been Chapside. In old Scots, a chap was a shop and a chapman was a shop-man or a market trader. The 1970s changes included the demolition of a rare example of seventeenth- or eighteenth-century Scottish domestic architecture seen in the picture.

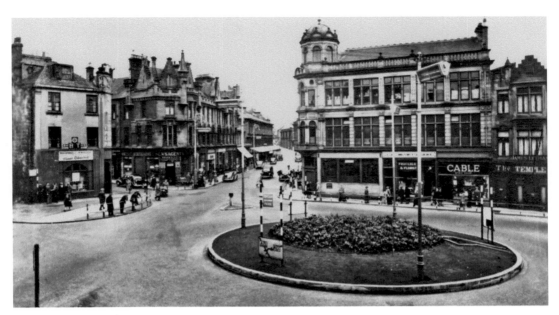

The Cross, 1950

This is how Kilmarnock Cross looked in 1950. The photographer is looking towards Duke Street. The whole of this area was demolished in the 1970s.

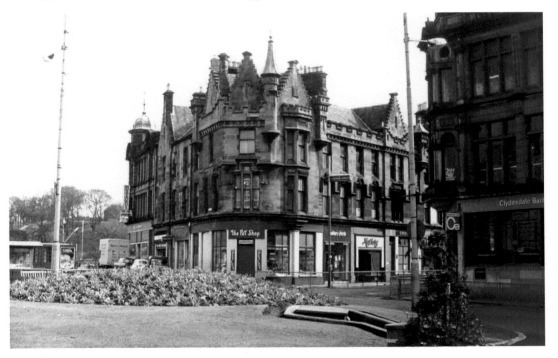

Duke Street

This is Duke Street with Regent Street to the left. The building with the magnificent architecture was a casualty of 1970s redevelopment.

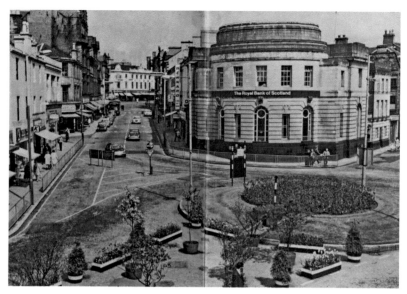

The Cross, 1972

The street on the left is Portland, much of which has been demolished. The Royal Bank rotunda building still exists, although it is no longer a bank.

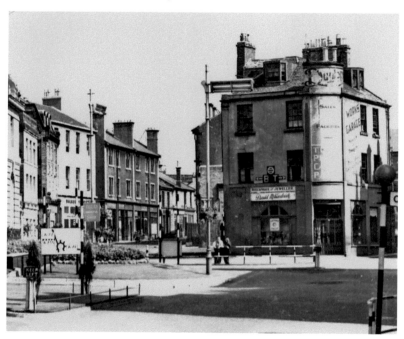

Fore Street

Fore Street existed before 1550, when it was called the Foregait, being the most important entrance to the town. It was one of the first streets to be demolished in the 1970s, though by then it had been renamed Fore Street. It was replaced by the Foregate shopping parade. At the time this was mostly for businesses displaced by the demolition of other streets.

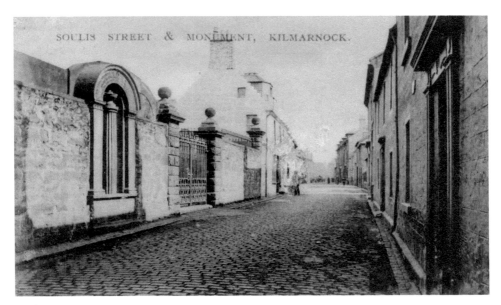

Soulis Street

Soulis Street is one of the oldest streets in Kilmarnock and part of the line of it still exists. It is named after a Lord Soulis, but history is vague about him. Along with Fore Street and High Street, Soulis Street formed part of the main thoroughfare through Kilmarnock on the route between Glasgow and Ayr. The original Soulis Cross, presumably a market cross, is said to have been dated 1444. The Soulis Monument in this picture is still in place, but the other buildings have been removed.

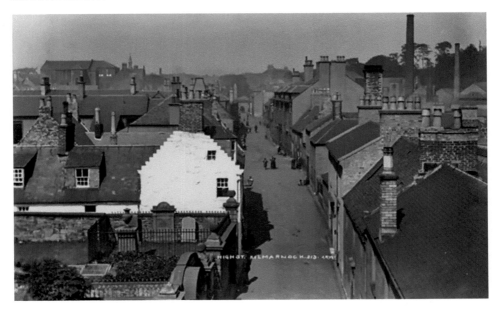

High Street

High Street was an extension of Soulis Street. In this picture you can see the top of the Soulis Monument featured in the previous picture, but the rest of the buildings have been cleared away.

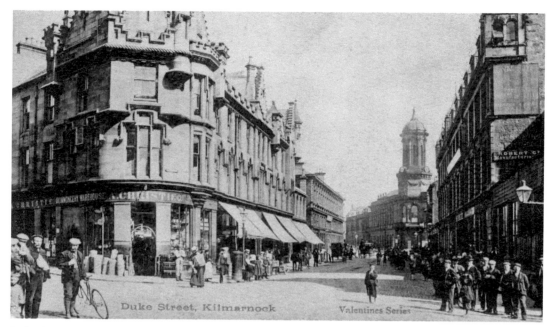

Duke Street

Duke Street was opened in 1859 as the entrance to the town from the east, linking the Cross to London Road. It consisted of fine architecture but was demolished in 1973 to make way for the Burns shopping centre.

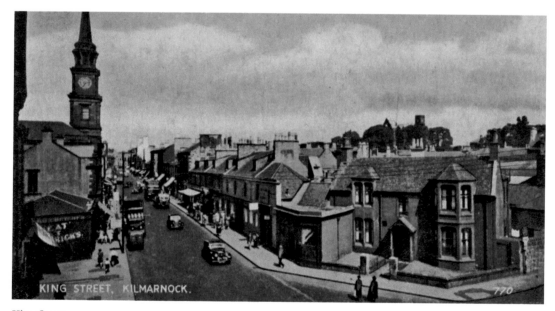

King Street

This 1959 image of King Street gives an idea of how much change has been made since then. The church and shops on the left are all gone and on the right, the prominent corner building and shops have all been demolished and replaced with other buildings.

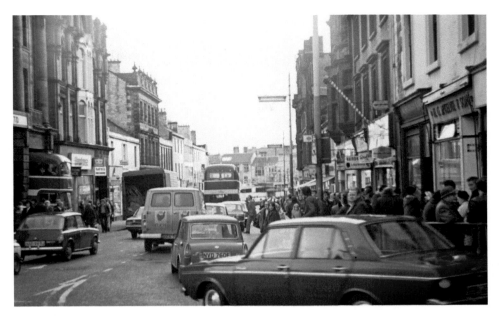

Portland Street

Portland Street was opened up as an extension to King Street, but as with many of the rest of the town centre streets, nearly all the buildings seen in this picture were swept away in the name of progress.

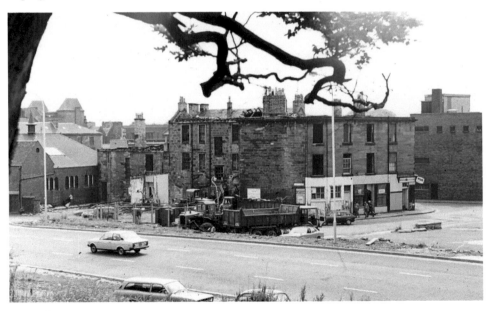

Queen Street

Queen Street was named after Queen Victoria. It is at right angles to King Street and was once of much greater importance than it is today. It was once a commercial and residential hub. It had the Queen Street Cafe, owned by Tommy Bertolotti. Much of Queen Street was demolished and now forms a car park, but today there are two buildings which were given listed status in 2002.

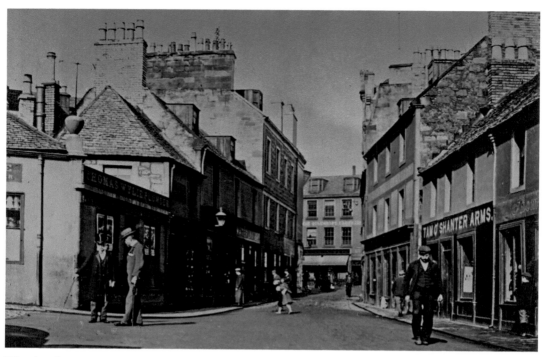

Waterloo Street

Waterloo Street was a narrow lane until reshaped into a street in 1752. It was renamed to commemorate the many local men who fought in the Battle of Waterloo in 1815. John Wilson established a printing press here and in 1786 printed the Kilmarnock Edition of the poems of Robert Burns. The street was demolished in 1973 to make way for Burns Mall.

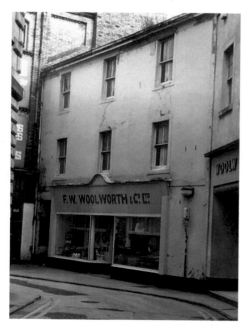

Market Lane

Market Lane originally led to the flesh market. After King Street was opened in 1804 the remains of Market Lane became just one of the minor lanes off the new street. Here was the Angel Inn which later became the Angel Hotel. Before the building was demolished in the 1970s it was part of Woolworths.

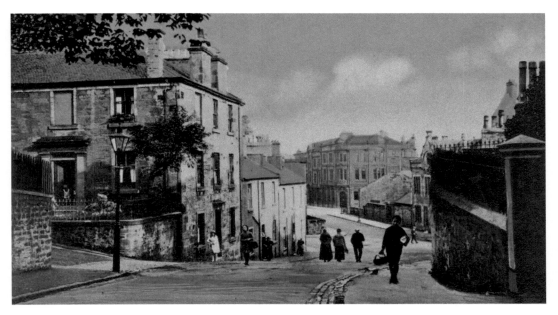

Park Street

The line of Park Street still exists, but buildings in this picture have been replaced. As with Park Lane, the name may have come from local property owners. Park Street was popularly known as the Gas Brae because the gas works were here.

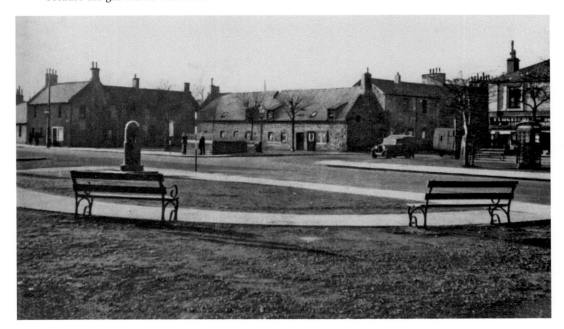

Glencairn Square

Glencairn Square was opened in 1765 and until the twentieth century was the Holm Square. In April 1800 fire swept through here, destroying houses and the Holm School. This is how the north-east corner of the square looked in the 1930s. Today this is the site of a supermarket.

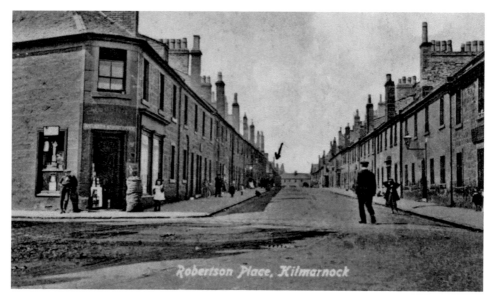

Robertson Place

In 1824 the Kilmarnock Building Company was formed. Members paid an entry fee and a monthly subscription to pay for the building of houses. The first street they built was Robertson Place, named after James Robertson on whose land it was built. These properties of Robertson Place were demolished and rebuilt in the 1960s.

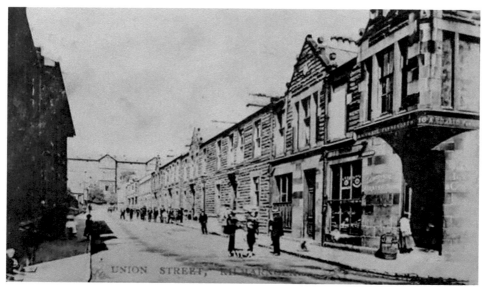

Union Street

Union Street linked High Street and Back Street. It was later given a short extension to meet Wellington Street. Union Street was opened in October 1860. It may have been named after the Union Brigade (Scots Grays) who fought at Waterloo. The opening ceremony included a volley of shots being fired. Union Street had a bonnet-making factory run by a Mr Stewart. The street was home to the Union Street Hall and the Union Street School.

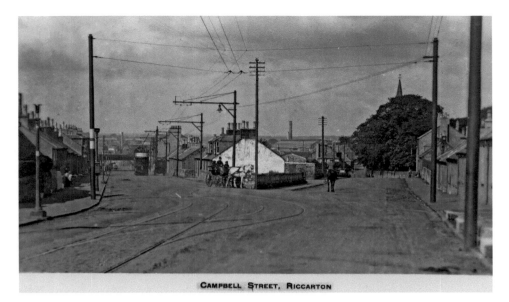

CAMPBELL STREET, RICCARTON

Campbell Street

Campbell Street forms part of the main route through Riccarton from Kilmarnock to the Ayr Road. It is named after the Campbell family of Loudoun. Everything has changed here. The town's fire station is here and there is also a plaque marking the connection with the Wallace family of Riccarton who did so much to ensure Scottish independence.

Greenholm Street

Greenholm Street is a descriptive name for what was once a flat grassy area near the River Irvine close to what is now the Riccarton Bridge. There was a quarry near here known as the Holm Quarry. The area became home to Barclay's engineering works and later Caldwell's 'ginger beer' works. In 1904 the burgh power and tram depot were opened on this site. Their distinctive building has now been demolished.

Armour Street

Armour Street ran from Titchfield Street to the junction of St Andrew Street and Gilmour Street. It was built in the 1870s and consisted mostly of white-sandstone tenement homes. It was named after Stuart Armour in recognition of his services to the community. The original street was demolished in the 1970s.

Old Cast Lane

The name Old Cast Lane probably relates to a cast, or dyke, on the bank of the Kilmarnock Water. Before Titchfield Street was opened as a wide straight road, Old Cast Lane was an extension of the Sandbed and as such would have been part of the main thoroughfare through the town. The former headquarters for the 4th Battalion of the Royal Scots Fusiliers was opened in 1914 on the corner of Titchfield Street and Old Cast Lane. It still stands. The commander's home, seen here, was used by the Ayrshire Samaritans from 1964 to 2017. It was demolished in July 2019.

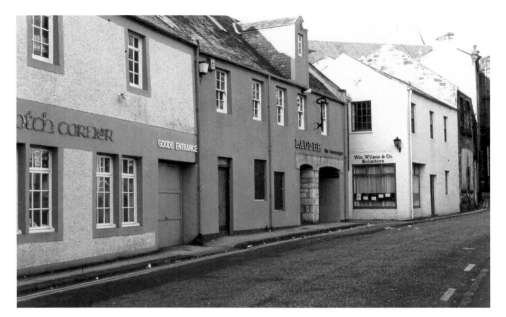

College Wynd

College Wynd is one of the oldest streets in town and still exists today. It takes its name from a school which probably opened in 1641. It was attached to the parish church, now the New Laigh Kirk. Like so many other streets, the businesses are constantly changing and none of the three main businesses seen in this picture are still in the street.

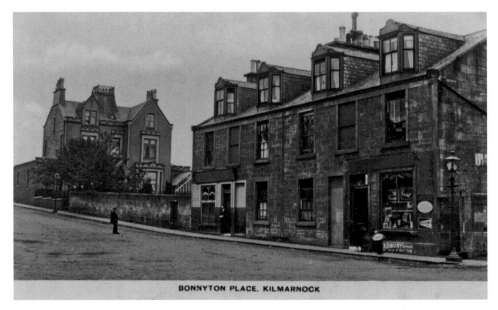

BONNYTON PLACE. KILMARNOCK

Bonnyton Place

Bonnyton Place was at the top of Bonnyton Road just off Warwickhill Road, opposite Busbiehill Place. The buildings here were cleared in the 1970s and replaced with housing. The odd shape of the new houses meant they were quickly nicknamed the Toblerone homes.

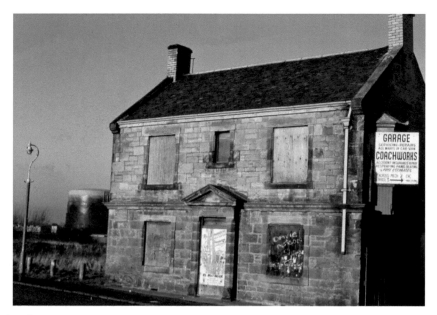

Fleming Street

Fleming Street is in Riccarton and was demolished as part of sweeping 1970s 'improvements'. The plaque on this building marked the site of Riccarton Castle. It was removed during redevelopment and was built into a feature at the Campbell Street fire station in 1994.

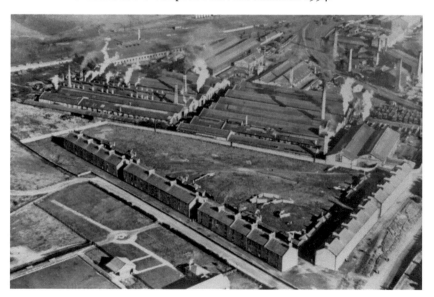

Bonnyton Square

In 1856 the Glasgow & South Western Railway confirmed Kilmarnock as a key railway town when it transferred its workshops from Cook Street, Glasgow, to Bonnyton. At around the same time the company began building homes for their workers at Bonnyton Square and other parts of Bonnyton. These houses were demolished in 1966 and 1967, long after the railway company had disappeared.

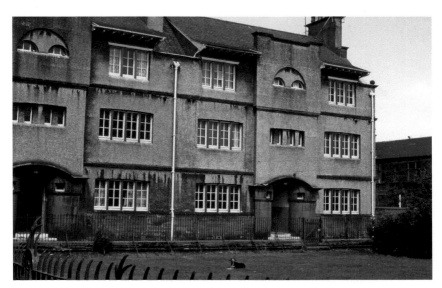

Hood Street

Another major employer who built houses for their workers was Johnnie Walker, the well-known whisky maker. Hood Street was laid out late in 1903 and was named in honour of Provost James Hood, who at the time was overseeing the introduction of public electricity and a tram system for the town. The Walker buildings were constructed in the 1920s and had several unique features. After years of neglect by the local authority they were controversially demolished in 1993.

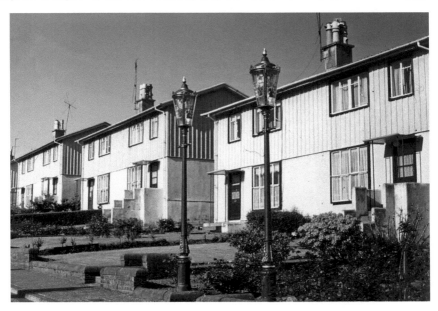

Samson Avenue

Council housing was built at Samson Avenue in 1948. In the 1970s Kilmarnock had its own town council and it was the practice to put two lamps outside the home of the provost and leave one there after a new provost had been appointed. The last provost of Kilmarnock Town Council was Annie Mackie. One lamp is still outside her former home in Samson Avenue.

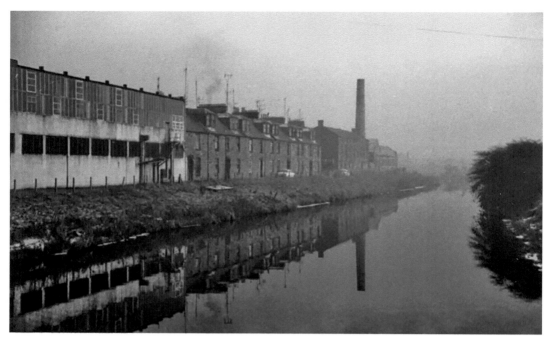

Victoria Terrace

The original Victoria Terrace was a row of tenement buildings on the bank of the River Irvine. They were prone to flooding. Houses here were demolished in the 1970s.

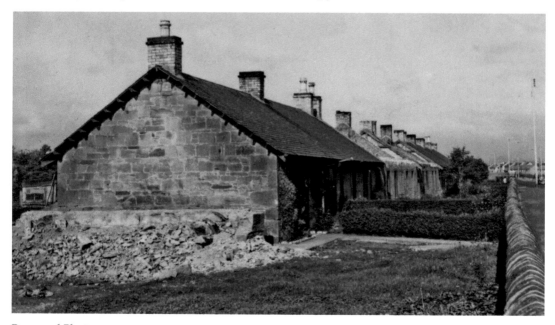

Peace and Plenty

Peace and Plenty was a row of miners' cottage a mile south of Riccarton on the Ayr Road. It was the last of the local miners' rows to be demolished.

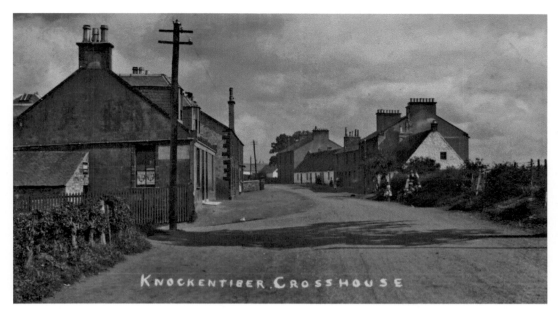

Knockentiber

The little village of Knockentiber grew up because of the needs of the coal industry. Nearly everything in this picture has been removed but the village remains as a vibrant community.

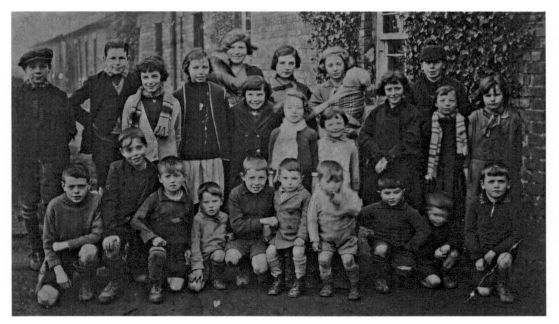

Kelk Place

Nothing remains of Kelk Place. Pronounced Kelt, it was a group of thirty miners' cottages near Kilmarnock on the Irvine Road, between Kilmarnock and Crosshouse, opposite Annandale. The houses were owned by the Caprington Coal Company. The picture shows some of the many children who once lived in the community.

Barleith Blocks

The Barleith Blocks were originally built by the Glasgow & South Western Railway Company as housing for their workers and their families. They were demolished in 1964. The G&SWR depot at Barleith was the company's main one, but the Beeching cuts saw the closure of various railway lines, stations and other facilities and the railway depot at Barleith was closed in 1966.

2

Lost Industries

"Born 1820 ——
Still going strong"

Goes everywhere

Johnnie Walker

It was just a grocery shop in 1820 and a teenage John Walker learned the art of blending tea and blending whisky. Less than 100 years later the business concentrated on whisky and Alexander Walker, grandson of John Walker, rebranded the Old Highland Whisky, naming it Johnnie Walker whisky. The business grew rapidly and exported to every country where alcohol was a legal product. But production of whisky ended in Kilmarnock in 2012 when the parent company, Diageo, closed the plant at Hill Street with the loss of 700 jobs and transferred the brand to other facilities.

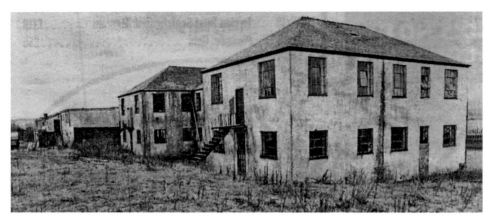

Bowhouse

Bowhouse was a munitions depot near Hurlford, used by the Ministry of Defence at the time of the Second World War. The properties were demolished and in a controversial move in 1999 the UK government allowed the establishment of HM Prison Kilmarnock, Scotland's first privately operated prison. In 2024 it was announced that HMP Kilmarnock was to be taken into public ownership.

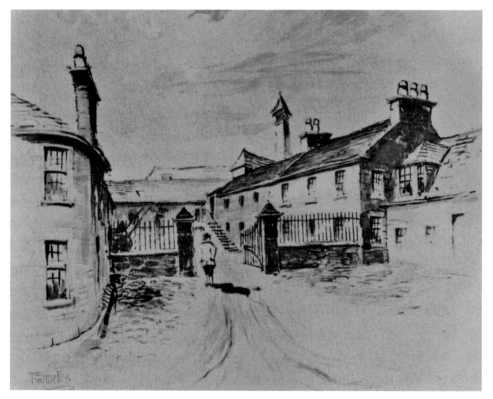

Breweries

At the start of the twentieth century Kilmarnock had two breweries. The Kilmarnock Brewery, pictured, was established in 1780 at Grange Street by Thomas Greenshields. It lasted into the early years of the twentieth century.

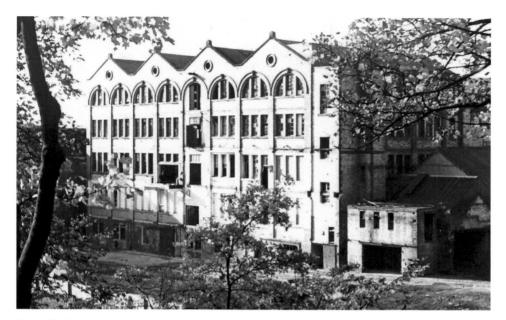

Bishopfield

In 1820 Hugh Wilson established his carpet-making business in Kilmarnock. The business became one of the most important in Kilmarnock during the nineteenth century and by the 1930s the fifth generation of Wilsons was running the company at the Bishopfield Mills in Kilmarnock. The buildings were in use up to around 1970.

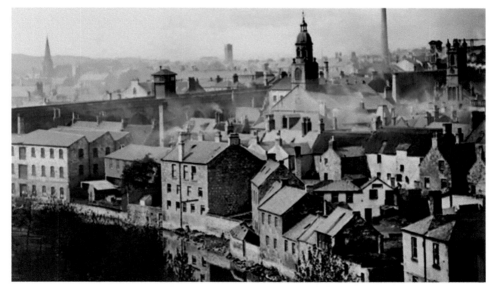

Ladeside

A lade once ran from the Kilmarnock Water to an old mill at the Cross. The mill was removed in 1703, but the names involved continued. Ladeside Street was originally beside that lade close to the railway viaduct. It was a busy area, crowded with factories. There were still a few commercial properties there in the 1970s but all have now been cleared.

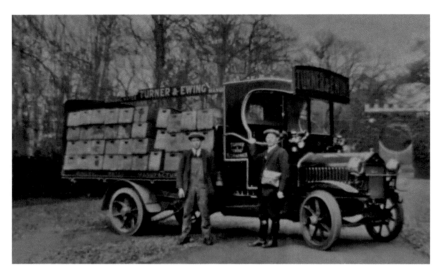

Turner and Ewing

Turner and Ewing was founded in 1810. The core business was bottled beers and soft drinks, but in the nineteenth century the company was also a spirit dealer and a cork manufacturer. They were agents for Bass and Burton's and they bottled a wide variety of well-known drinks such as Guinness. From the 1960s the company concentrated on soft drinks, producing more than twenty flavours. In the 1930s the business moved from their base at Mill Lane to Tannock Street, where they remained until closure in 1984.

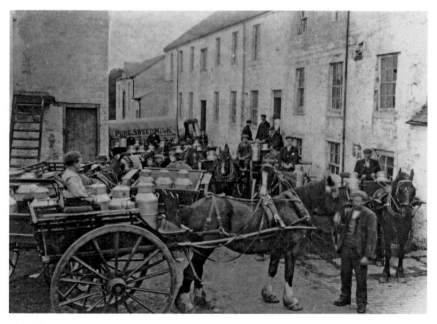

Waterside Creamery

Ayrshire was an agricultural county and was a major producer of dairy products. The village of Waterside near Fenwick once had an extensive creamery which took milk from farms all around Ayrshire.

Rowallan Creamery

Another major creamery was at Rowallan at the northern end of Kilmarnock. It was established by John Wallace as a 'butterine' factory in 1886. It later produced leading brands such as Banquet Margarine. The creamery closed in 2003 and the buildings were demolished to make way for forty houses.

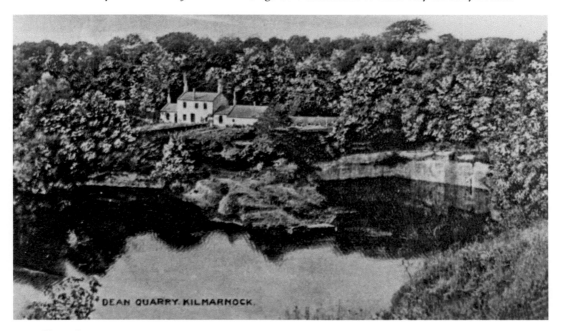

Dean Quarry

The tile and fireclay works, which had been established by Matthew Craig at the Dean in 1828, were transferred to a new local base at Hillhead in 1860. The Dean continued as a quarry until 1972. The reclaimed area is now part of the Dean Castle Country Park and has an adventure playground and animal paddocks. Part of the quarry area has been retained as a pond for ducks and swans.

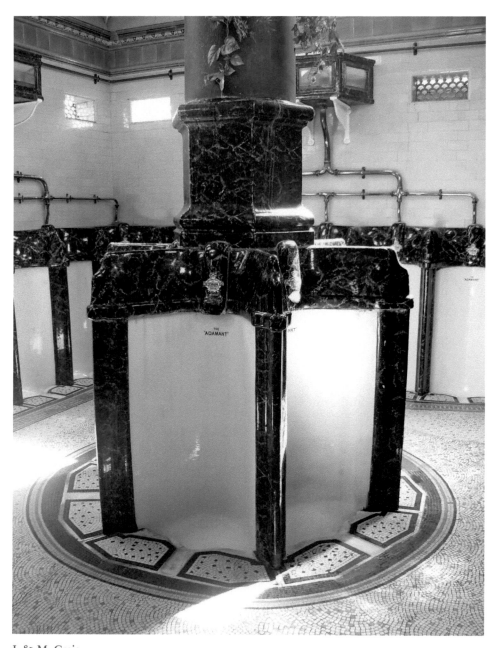

J. & M. Craig

Kilmarnock had a long tradition of brick-making and stone quarrying. These businesses also made chimney pots, garden ornaments and features for public parks. Some of the local parks retain stone lions as a silent reminder of that industry. The tile and fireclay works established by Matthew Craig was at the Dean from 1828 until it was transferred to a new local base at Hillhead in 1860. The picture shows the gents' toilet at Rothesay. It is highlighted as an outstanding example of Victorian industry and is regularly closed as a toilet to allow visitors to marvel at the craftsmanship of the bricks and tiles.

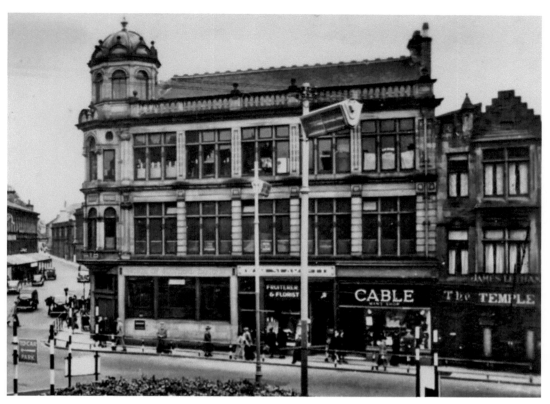

Bank Building

Another example of fine architecture lost in the 1970s is this bank building, which was on the corner of Regent Street and Duke Street at Kilmarnock Cross.

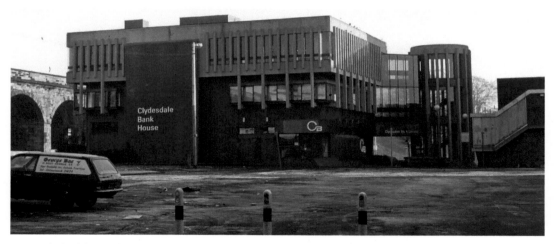

Clydesdale Bank

The 1970s redevelopment saw the relocation of some banks which tended to occupy some of the most prestigious buildings in the town centre. In 1975 The Clydesdale Bank moved to new property at the Foregate. In 2021 the bank was rebranded as part of Virgin Money.

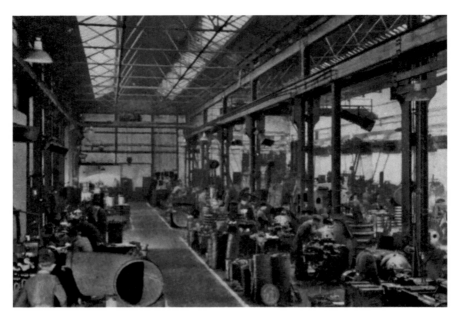

Barr Thomson

Barr, Thomson & Co. had its origins in the Netherton with an engineering company founded in 1884 by James Barr. This firm later became Barr, Thomson and was based at Little Bellsland Road.

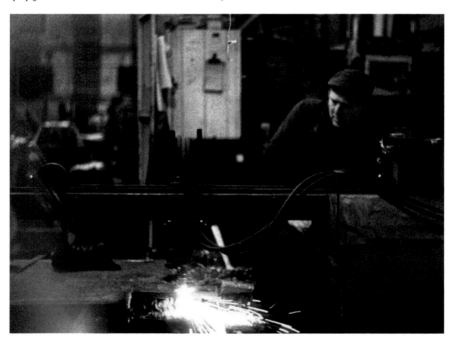

Andrew Barclay

Andrew Barclay, 1814–1900, was a brilliant engineer who could turn his talents to any problem posed by customers. His business was founded in 1840. The later business of Andrew Barclay Sons & Co. tended to specialise on the production of specialised industrial locomotives.

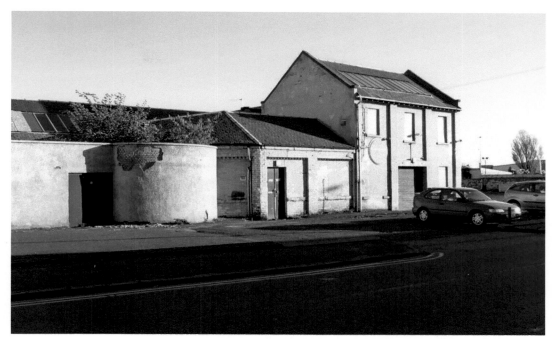

Trademarket

Another commercial business that is now lost was the popular Trademarket. This was a cash and carry business in New Mill Road, providing goods to small local businesses for resale. The site is now occupied by houses.

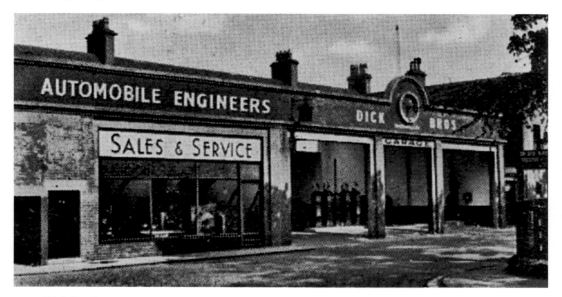

Dick Brothers

The local business of Dick Brothers, bicycle and, later, motor dealers, was established in 1895. This was the year that the first motor car was brought to Scotland. In 1897 Dick Brothers started operating the first motor bus service in Kilmarnock on the route from the town to centre to Hurlford.

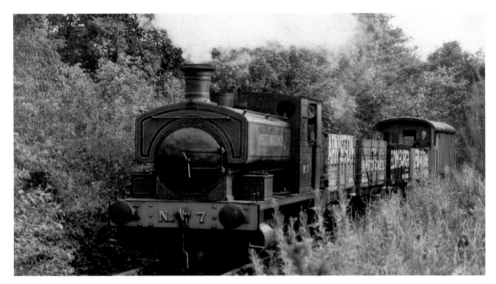

Grant, Ritchie

The Kilmarnock engineering firm of Grant, Ritchie & Co. was closed in 1926. It had been founded in 1876 by Thomas Maxwell Grant and William Ritchie, two former employees of Andrew Barclay. The other partner in the business was James McAlister. The new firm dealt largely with mining equipment and tram works but also built locomotives.

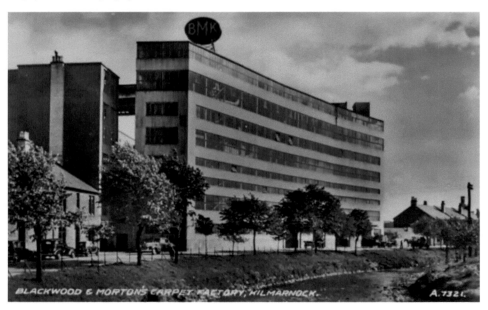

BMK

BMK was founded in Kilmarnock and had a reputation at home and abroad for high-quality carpets. They provided carpets for the Oval Office at the White House and for the film set for *Titanic*. Once again it was cheap imports that hit the company hard and resulted in contraction and ultimate closure. The picture shows the company's landmark building in Burnside Street, now demolished.

Glacier Metal

With a generous government grant Glacier Metal moved to a new site at Riccarton in 1947 on the land of the former Kirkstyle coal pit. In 1942 the company had moved from London to a temporary factory in Kilmarnock to escape from possible damage from air raids. At one time the company employed 1,200 in Kilmarnock and had its own Glacier Social Club. Today, operating as Mahl, the company produces specialised ball bearings.

Glenfield and Kennedy

Thomas Kennedy established two companies in Kilmarnock which were eventually merged to form Glenfield and Kennedy. The company grew rapidly and provided valves and street water fountains across the world. During the Second World War, they provided the floodgates that allowed London Underground stations to be used as bomb shelters. In later years The Glen, as everyone called the business, could not compete with cheap foreign competition and most of their extensive works were demolished. Only a small part of the once mighty company remains.

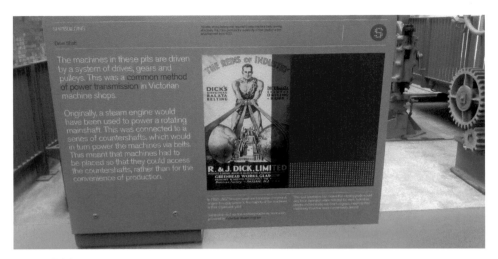

R. & J. Dick

Brothers Robert (1820–91) and James (1823–1902) Dick were born in Kilmarnock but the family moved to Glasgow when the boys were still very young. In 1846 they set up R. & J. Dick to exploit the new rubber substance from North Borneo called gutta-percha and soon started using it as a substitute for leather soles in shoes. Later gutta-percha was used for golf balls, electrical insulation and drive belts. The company grew and the brothers became wealthy. James paid for the Dick Institute in his home town as a memorial to Robert.

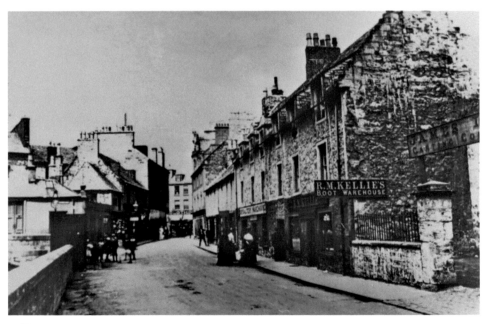

Kellie & Co.

The boot and shoe making firm of R. M. Kellie & Co. was founded in Kilmaurs in 1887. It grew to become a major employer in the village and the area around it. The picture shows when they had a shop in Waterloo Street, Kilmarnock. In later years it was absorbed into the Kilmarnock boot and shoe making company Saxone.

Saxone

Kilmarnock had a long history of making boots and shoes. Eventually one company emerged to dominate the industry. Saxone was founded in Kilmarnock and had a reputation for quality shoes. They had a chain of shops around the UK, but Saxone could not compete against cheap foreign imports and in the middle of the 1980s the Kilmarnock factory site was cleared to make way for the Galleon Leisure Centre.

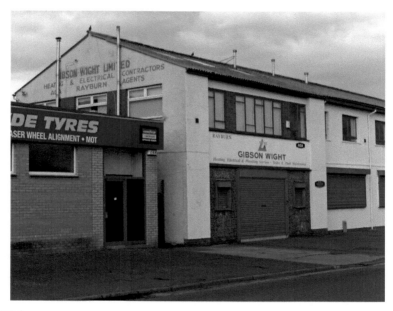

Gibson-Wight

The local firm of Gibson-Wight, electrical and heating engineers, had its roots in two businesses. Sam Gibson started his company in 1924. In 1966 his son William Gibson took over a similar business that had been established by John Wight. The two businesses were merged in 1971 to form Gibson-Wight. The firm closed in 2018.

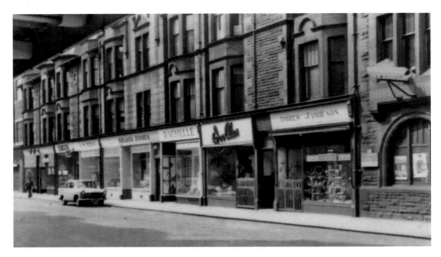

Kelso

John M. Kelso opened his paint and wallpaper shop at No. 11 Queen Street in 1929, and in 1959 moved the business to Titchfield Street (pictured). The business remained there until 2004, when it became Kelso House to Home and moved to the Forge Industrial Estate off West Langlands Street, at which time the business was run by the third generation. The move did not pay off and the business closed in 2007.

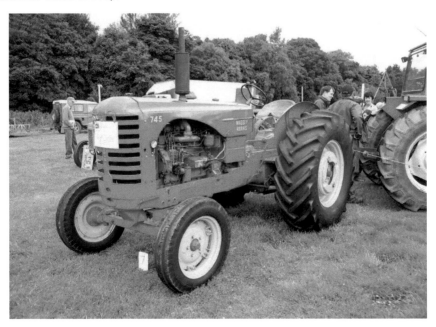

Massey Ferguson

In 1949, with the help of government grants, tractor builders Massey Harris established an assembly plant at Moorfield Industrial Estate between Kilmarnock and Gatehead. It rapidly grew to become one of the major employers in the area. The company later changed its name to Massey Ferguson. In 1980 Massey Ferguson closed their Kilmarnock plant with the loss of 1,500 jobs. It was one of the most severe blows Kilmarnock industry has ever suffered.

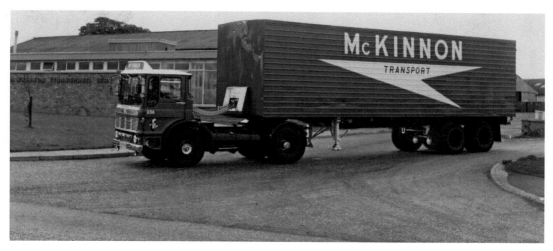

McKinnon

James McKinnon set up his own transport business in Kilmarnock with other members of his family in 1933. Until just two years before his death in 1987 he was involved in the running of the family firm of McKinnon Transport. Sadly, this is yet another business that is now lost.

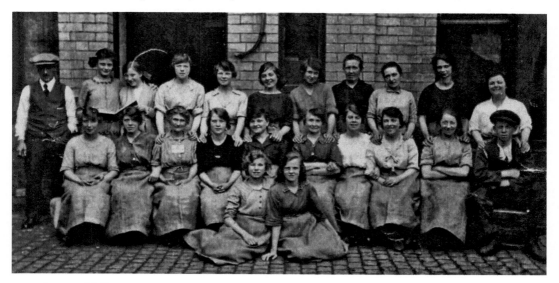

Jams and Jellies

Gilmour and Smith was founded in 1877 and grew rapidly, selling jams, jellies and other preserves to a wide area of the country and ultimately to many other countries. In 1886 they opened new works in Low Glencairn Street. The business closed in 1932.

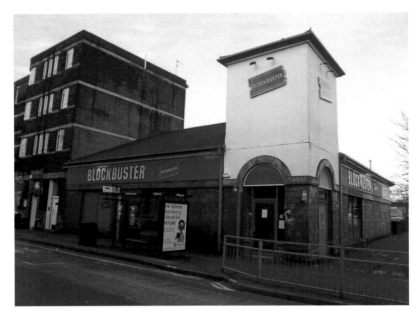

Blockbuster

Blockbuster was seen as one of the modern go-ahead, new technology companies and offered video and game hire. Technology, however, outpaced it and after a number of years in Titchfield Street Blockbuster was closed in 2013.

Jaeger

Towards the end of the 1960s, the pattern of the emergence of new businesses had changed. Emphasis was now on attracting established businesses to set up in the town. In 1968 Jaeger came to Kilmarnock and established a temporary factory making clothes. The business soon started expanding in Kilmarnock. Like so many others, this company is now lost to Kilmarnock.

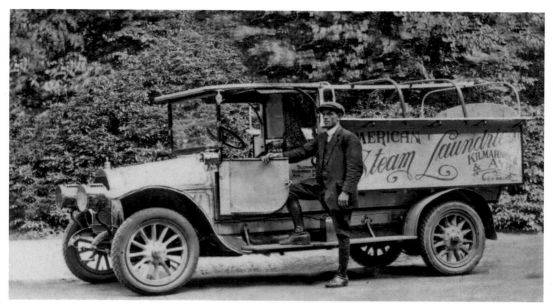

Steam Laundry

An American Steam Laundry was established in Kilmarnock in 1891. In 1913 they were based at New Mill Road, Kilmarnock, and at Wallace Street in Ayr. At that time the proprietor was H. H. Wallace and the manageress was a Miss Wallace.

Watson

John Watson was an engineer who left Ireland in 1874 and came to Kilmarnock. He set up business in West Netherton Street. His company, John Watson & Son, engineers, made band saw machines and woodworking machines.

3

Lost Transport

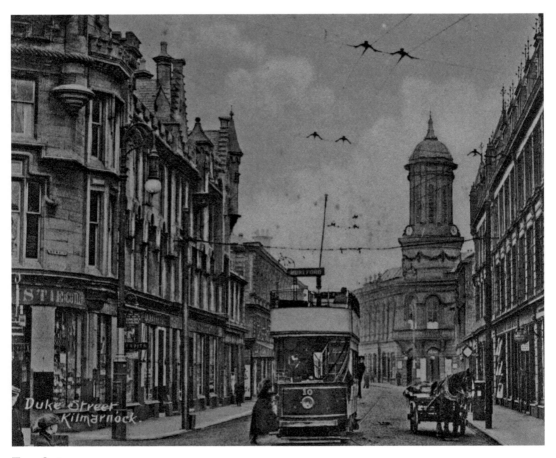

Tram System

Kilmarnock had a small tram system from 1904 to 1926. The first trams were all open-topped. A few trams added to the fleet had closed tops and were always referred to as double-deckers. The system ran from Riccarton in the south to Beansburn in the north and from Kilmarnock Cross to Hurlford.

Railway Station

While Kilmarnock had a railway from 1812, complete with a timetabled passenger service, the town was not connected to the national rail network until 1843. That was when the Glasgow, Paisley, Kilmarnock and Ayr Railway opened the branch from Kilmarnock to Dalry and, therefore, to Glasgow. The opening was celebrated by a lunch at the George Hotel. The station building was demolished 1995.

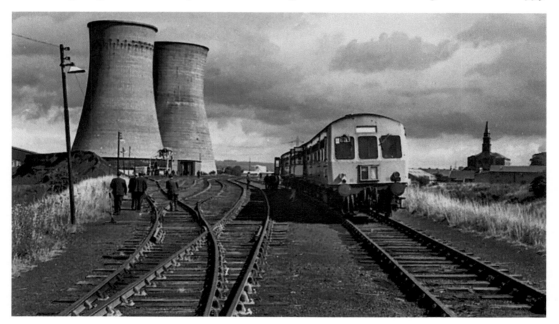

Riccarton Line

The Riccarton railway loop line was opened for freight in 1904. Although a station was provided, the early plans to use it for passengers were put on hold because of competition from the tram system. This passenger train was a special hire by railway enthusiasts. The line has since been replaced a road.

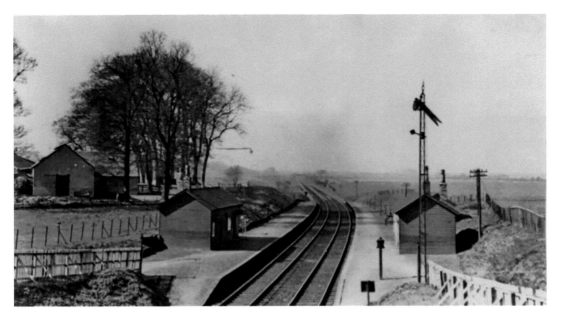

Springside Station

The railway line from Kilmarnock to Irvine, via Crosshouse, Springside and Dreghorn, was one of the casualties of the 1960s Beeching cuts.

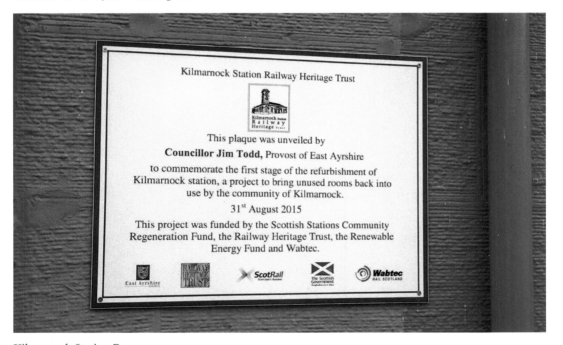

Kilmarnock Station Revamp

In 2015 Kilmarnock railway station was given a revamp with rooms that had been neglected for forty years being brought back into use. It is strange that the plaque commemorating that has now disappeared.

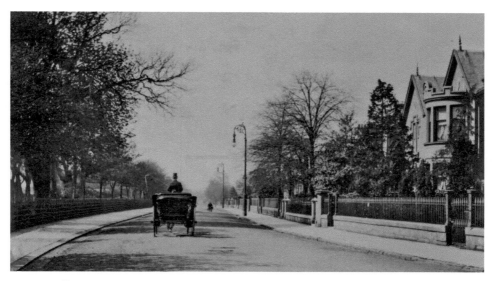

Horse Traffic

Horse traffic is now rare. This image, taken in Dundonald Road around 1905, perfectly captures that lost era.

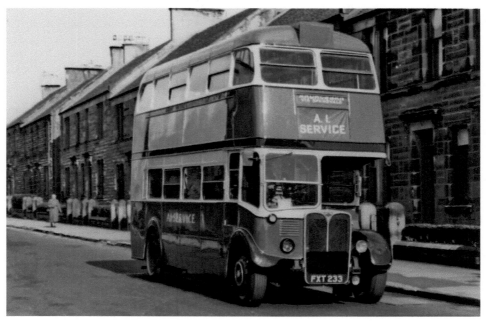

A1 Buses

The A1 bus service of the Ayrshire Bus Owners Association was formed in 1925 and started services in 1926. It was a kind of co-operative of owners from Irvine, Kilmarnock, Ardrossan and the Irvine Valley towns. In 1953 the A1 bus service started using a new stance in the St Marnock Street car park. It was their main Kilmarnock terminus until they moved to the corner of Cheapside Street and John Dickie Street in 1959. The group was taken over by Stagecoach in 1995.

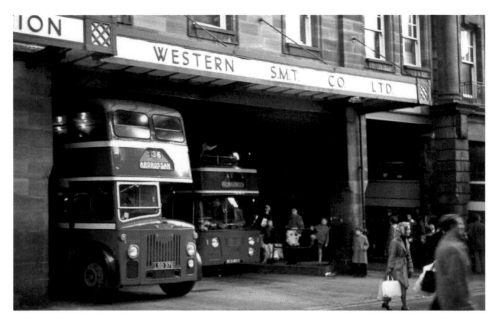

Western Bus Station

The town's main bus station was opened in Portland Street in 1923 and was one of the first custom-built bus stations in Scotland. It was used by Western SMT. Both this bus station and one in Cheapside Street for the A1 buses were replaced by a new station at Green Street in 1974. The new bus station is attached to the Burns Shopping Centre and it served both Western SMT and the A1 bus companies. Both these operators became part of Stagecoach.

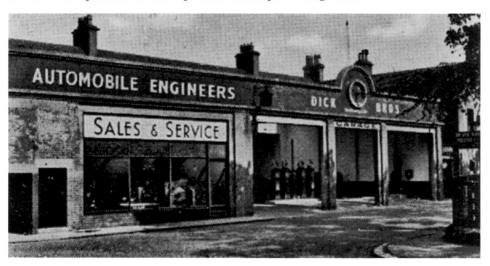

Motor Cars

Motor traffic grew quickly and soon dominated town planning and development across the country. The local business of Dick Brothers, bicycle and later motor dealers, was established in 1895. This was the year that the first motor car was brought to Scotland. Dick Brothers became one of the most important motor dealers in Ayrshire but went into decline in the 1960s and closed in the 1970s.

Car Parks

Finding car parking space was a problem, particularly in the town centre. From the 1960s, areas that had been cleared were often turned into car parks.

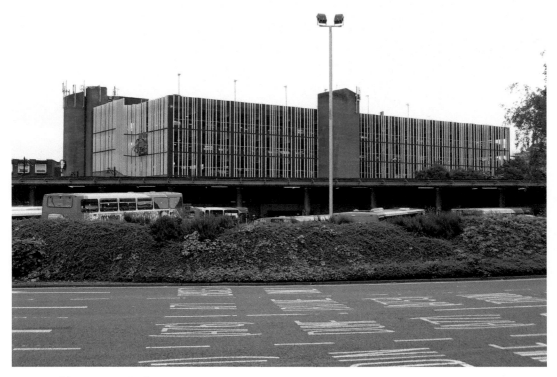

Multi-storey Car Park

Part of the 1970s redevelopment saw the construction of a multi-storey car park at the Foregate. At the time it was to be the first of several, but no others were ever built. This one had design faults which were not apparent until recently and in 2023, the building was scheduled to be taken down.

4

At Your Service

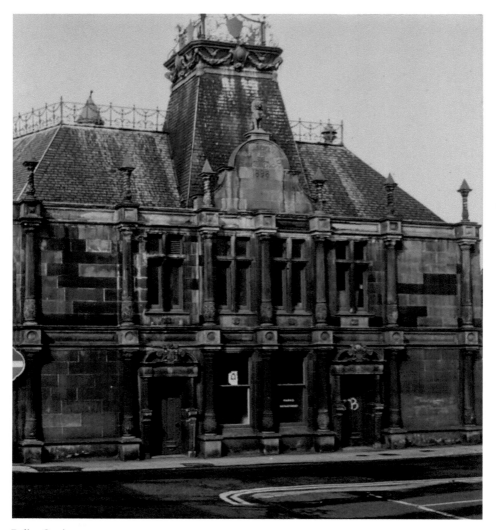

Police Station

Today Scotland is served by a national police organisation. Until the 1970s Kilmarnock had the local Burgh Police and the Ayrshire Constabulary. The picture shows the Burgh Police station, which was built in Sturrock Street in 1898. It was demolished in 1973.

Town Jail

The Ayrshire Constabulary used the former town jail in Bank Street. The Kilmarnock Burgh Police became part of Ayrshire Constabulary in 1968, and this became par of Strathclyde Police in 1975. A new divisional headquarters for the police in Kilmarnock was opened in 1978.

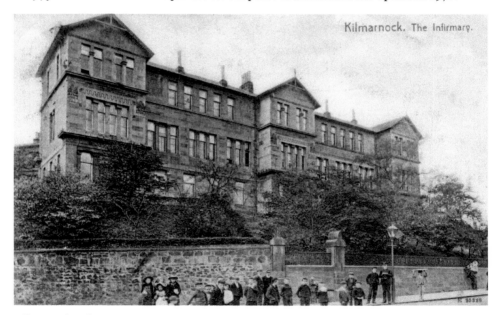

Kilmarnock Infirmary

The foundation stone of Kilmarnock Infirmary was laid at Mount Pleasant in Wellington Street in 1867 and the hospital opened in 1868. It was extended several times and in 1921 the original hospital building became a nurses' home. Hospital services were transferred to new buildings at Crosshouse starting in 1972 and the original building was later demolished. The site is now used for houses.

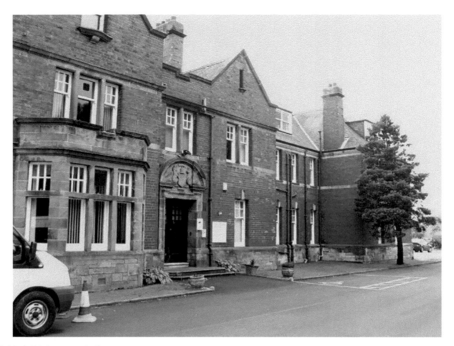

Kirklandside Hospital

Another hospital lost to centralisation was the facility at Kirklandside. Kirklandside Hospital was opened as a fever hospital in 1909 on land which at that time was on the very edge of town.

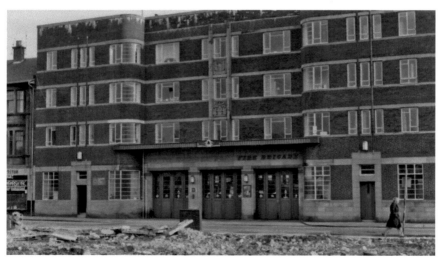

Fire Station

The town's new fire station was opened in Titchfield Street, Kilmarnock, in 1937, replacing three small units. The new station even had motorised fire engines with a novel feature –the firemen could ride inside the vehicle. The station closed in 1994 when a new station was opened at Campbell Street in Riccarton. The former fire station building was converted for commercial use on the ground floor, with nine homes on the upper floors. The development was named Brigade Court.

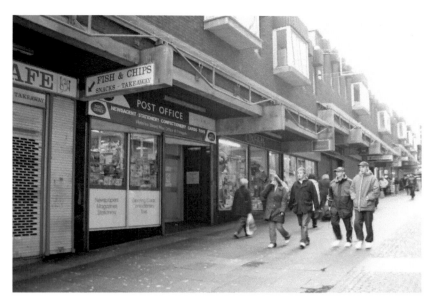

Post Office

One curiosity of the 1970s redevelopment was the Waterloo Street sub-post office. It had opened on 1 October 1967 to replace the Duke Street post office. Waterloo Street post office was itself relocated to the Foregate in 1974 but it retained its Waterloo Street name. Outside the front door there is a large flagstone in the form of an addressed letter. It closed in 2022.

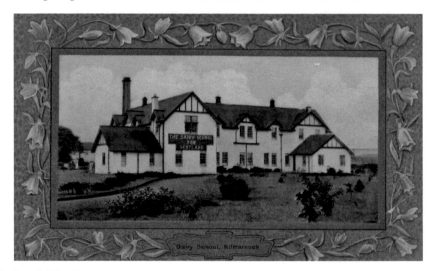

Agricultural School

Ayrshire was a major agricultural centre and in 1889, the Dairy School for Scotland was built on land at Holmes Farm at Holmes Road, Kilmarnock. Eventually the school outgrew the buildings here and moved to Auchincruive. As well as a teaching facility, the Dairy School conducted experiments, including one attempt at finding a strain of tobacco plant that could stand the Scottish climate. The site became the Kilmarnock Maternity Home and later the Strathlea Resource Centre. Buildings were derelict when destroyed by fire in 2015. The site is now used for housing.

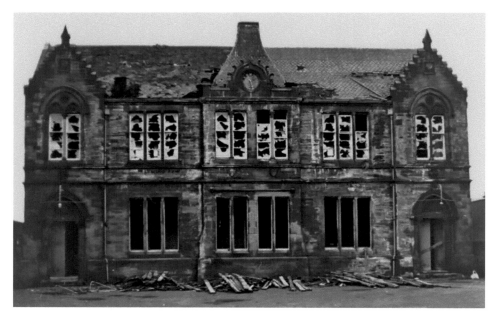

Glencairn School

Glencairn School opened as an elementary school in Low Glencairn Street in 1876 with accommodation for 400 pupils. Glencairn School's primary section was opened in 1925. It had five classrooms and a small assembly hall. In 1960 the old Glencairn Primary School in Low Glencairn Street was closed and most of the children went to Bentinck Primary School. The Gothic-style building was soon demolished and today the site is occupied by commercial properties.

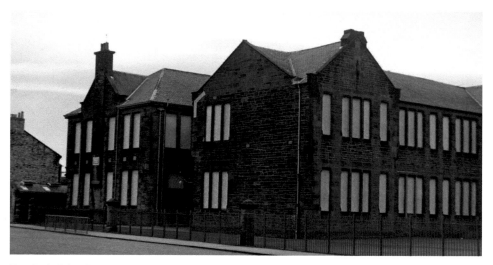

Bentinck School

The school on the corner of Bentinck Street and James Little Street was opened as one of two Kay Schools using money provided by Alexander Kay (1796–1866). It opened in 1869 along with the Wellington Kay School. In 1898 it was renamed and rebuilt as Bentinck School. There was an expansion in 1910. A new kitchen and dining room annex was added in 1974. In 1978 structural faults were discovered and children and staff were moved out. It was demolished in 2023.

St Columba's School

St Columba's School had two main buildings in Elmbank Drive. The school was merged with St Matthew's in 2008. The new school was named St Andrew's RC Primary School and was housed at St Joseph's Academy. The site at Elmbank Drive is now used for housing.

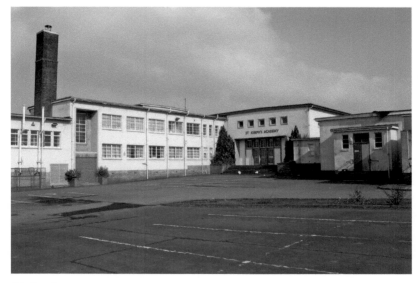

St Joseph's Academy

St Joseph's School was moved from Elmbank Avenue to Grassyards Road in 1955. The school had been in Elmbank Avenue since 1902. The primary department remained at Elmbank Avenue and became St Columba's RC Primary School. The original building at Grassyards Road was replaced in 2008. The new building also houses the primary feeder schools of St Columba's and St Matthew's which were merged to form a new St Andrew's RC Primary School.

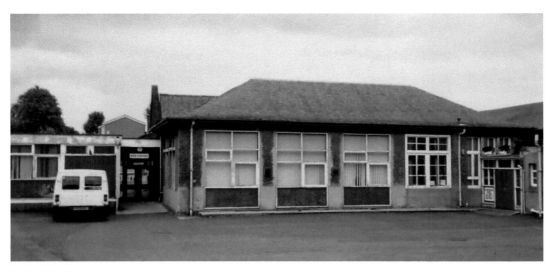

Park School

Park School was officially opened in 1928 with facilities to cater for one hundred physically and mentally handicapped children. It had been in use since the end of 1927. The school was later replaced with the Willowbank School which has better facilities for children who suffer from various physical and mental issues.

5

Lost Buildings

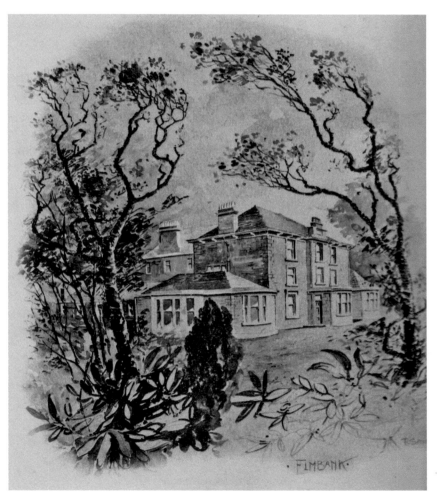

Elmbank House

The original part of the mansion of Lewisville was built in 1792 for James Gregg, joint town clerk of Kilmarnock. Later when the building was substantially extended, the name was changed to Elmbank House. The building was acquired by the town and used as a library, but when funding became available for a new building, Elmbank was demolished and what beam the Dick Institute was built on the site.

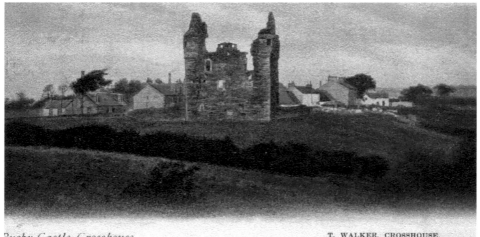

Busby Castle, Crosshouse.

T. WALKER, CROSSHOUSE.

Busbie Castle

The last remnant of Busbie Castle at Knockentiber was demolished in 1952 amid fears that the ruin might be unstable. The substantial part of the demised building probably dated from the end of the sixteenth century, though the first building on the site was built at the end of the fourteenth century.

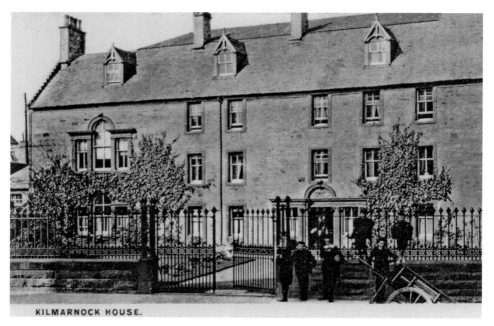

KILMARNOCK HOUSE.

Kilmarnock House

Kilmarnock House in Saint Marnock Street was demolished in 1935. The original part of the building was seventeenth century, and there were eighteenth-century additions. It had been the home of the Boyds of Dean Castle and later of the Earl of Glencairn. Later still it was an industrial school. Stone from Kilmarnock House was used in the restoration of Dean Castle. The site of the house was never redeveloped and is now a car park.

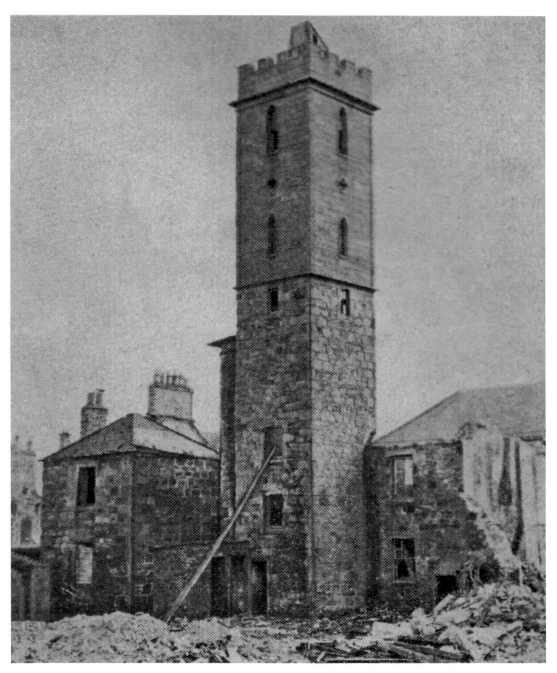

Observatory

Local engineer Thomas Morton took extensive lands on the edge of Kilmarnock and started his engineering works there. His great passion was astronomy and he built his own telescopes. In 1818 he built the Kilmarnock Astronomical Observatory at what is now Morton Place and equipped it with a camera obscura and two telescopes. One of the telescopes was designed for use during the day and the other for astronomical work at night. The building was demolished in 1957.

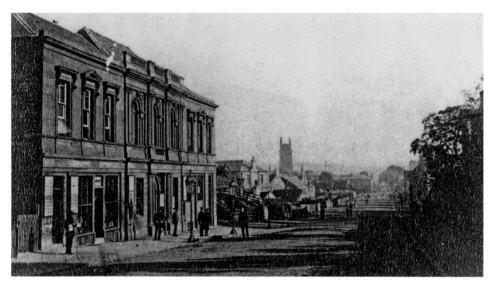

Opera House

In 1875 an Opera House was opened in John Finnie Street under the management of William Glover of the Theatre Royal in Glasgow. It was the first purpose-built theatre in Kilmarnock and had seating for 1,200 patrons. The building later served as a church and a nightclub. The building was destroyed by fire in 1989 with only the facade remaining. The site lay derelict for many years until being redeveloped with the original facade retained.

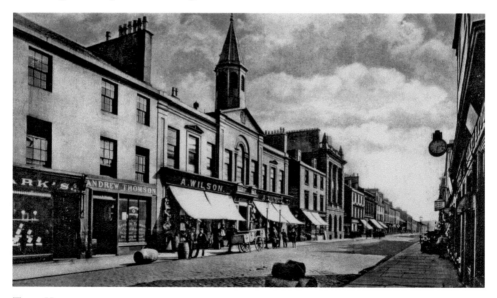

Town House

The Town House was built in 1804–5 as the civic headquarters for the town on a site in King Street on the new bridge over the Kilmarnock Water. The architect was Robert Johnstone. The building included offices for the magistrates, the law courts and a jail. In 1828 the library room was converted to a police station for the new Burgh Police Force. The tower was removed in 1970 and the rest of the building was demolished just a couple of years later.

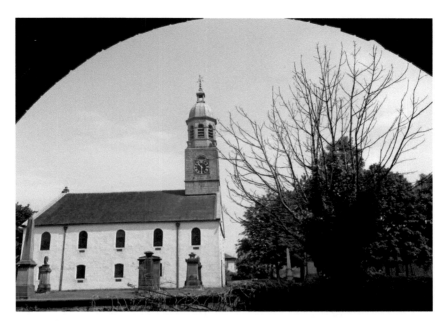

Old High Kirk

The Old High Kirk dates from 1731 when it was built to accommodate a growing population. The tower is a later addition. The kirkyard has stones to John Wilson, printer of Burns' works, Thomas Kennedy, founder of Glenfield and Kennedy, Thomas Morton, inventor, industrialist & astronomer, and John and William Tannock, artists. A six-year restoration was completed in 2007. The building is no longer used for worship, but is home to a funeral business.

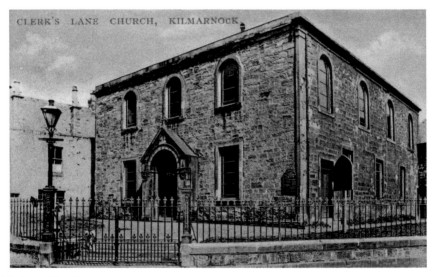

Clerk's Lane Church

In 1807 the congregation of the Clerk's Lane Church had outgrown the original building that they had constructed in 1774. They reconstructed the building on the same site to provide more room. The church closed in 1907 and in 1911 the building became the Electric Theatre, Kilmarnock's first cinema. This cinema closed in 1938 and the building was soon demolished.

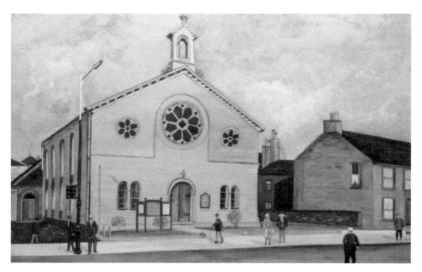

Portland Road Church

Portland Road Church was opened in 1859 when the congregation of the Gallows Knowe Church relocated there because of their need for bigger and better premises. In 1965 the congregations of King Street Church and Portland Road Church (pictured) were united under the name of the Howard Church. The King Street church building was demolished. The old Portland Road church was also soon demolished, but the proceeds from the sale of the buildings went to pay for a new Howard Church building in Portland Road.

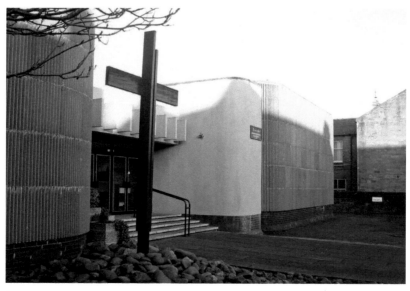

Howard Church

The new Howard Church building was opened for worship in 1971. In 1984 the congregation of St Andrew's North Church in Fowlds Street agreed to a merger with the congregation of Howard Church. Worship was in the Portland Road premises, which changed its name to Howard St Andrew's Church. Today the building is no longer used for worship, but remains as a centre for various church and community events.

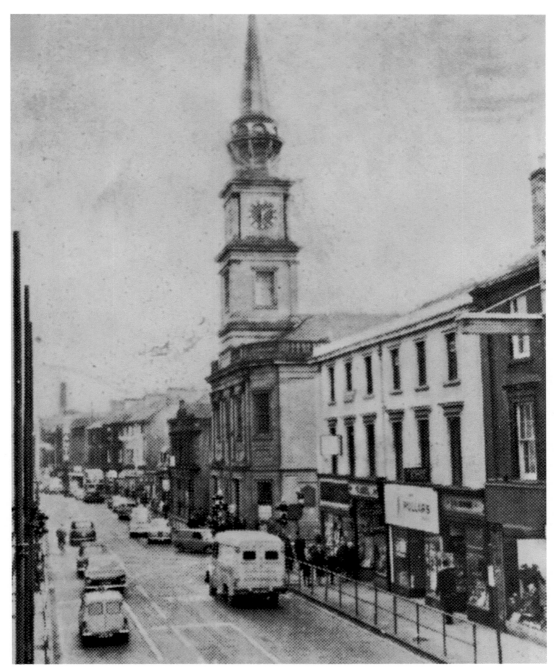

King Street Church

Construction work on King Street Church, on the corner of King Street and Saint Marnock Street, was completed in 1832. In 1966 King Street Church was demolished to make way for a row of shops. These shops have now also been demolished.

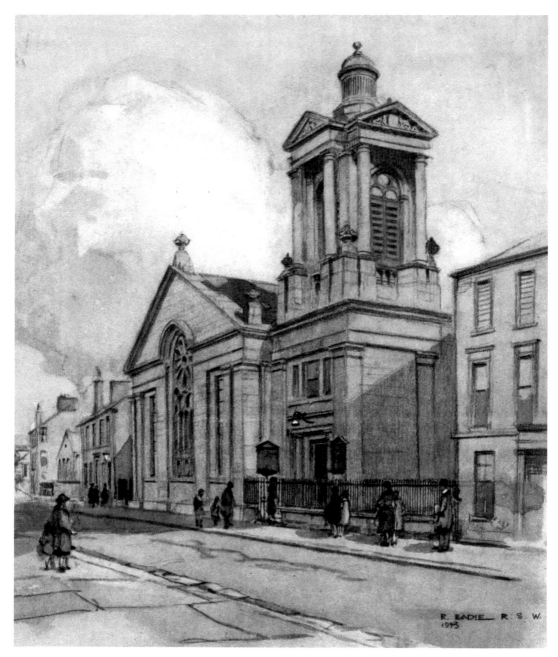

R. EADIE R. S. W.
1913

St Andrew's North Church

St Andrew's North Church was established in 1843 in a building in Fowlds Street. In 1929 the United Free Church and the established church merged. The United Free Church had ten congregations in Kilmarnock and had been formed in 1900 from the merger of the Free Church and the United Presbyterian Church. The established Church brought in another five congregations to the reformed Church of Scotland. This involved changing the name of the St Andrew's UF Church to St Andrew's North Church. The building was demolished in 1986. The site became a shop for Iceland.

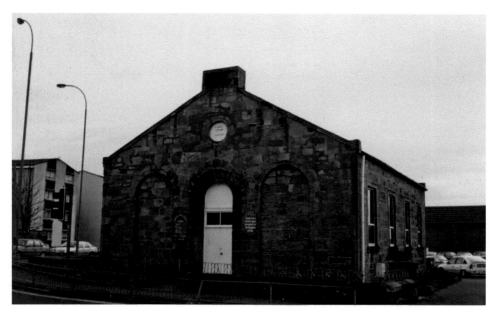

Sovereign Grace Church

The Sovereign Grace Church was built in 1857 at the junction of Fowlds Street and Old Mill Road and the building was used for worship until 2003. Since then the building has been used for various commercial purposes.

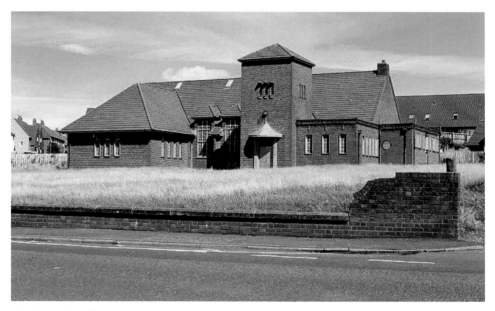

Shortlees Church

Shortlees was one of the first of the major new housing areas to be built around Kilmarnock after the Second World War. New communities need more than just houses and in 1953 Shortlees Church was opened for worship. Reflecting the shortages of the time, it was a plain building. Following a merger, the building was surplus to needs and was demolished in 2017.

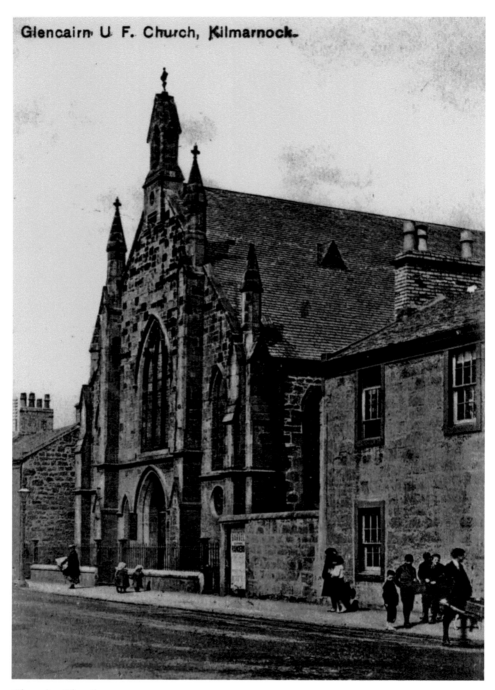

Glencairn Church

Glencairn Church in West Shaw Street near Glencairn Square dated from 1881. The building replaced the earlier Holm Church Mission on the same site. In 1967 the congregations of Glencairn Church and St Andrew's Churches united under the title of St Andrew's Glencairn. This building was then used by a neighbouring industrial firm, but it was demolished in 1993.

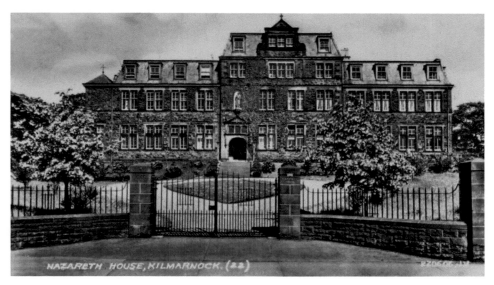

Nazareth House

Nazareth House was built on land that had been part of Hawket Park between Wellington Street and Hill Street. Early references give the address as Wellington Street, not Hill Street. It is noted as having been constructed in 1890 for the Sisters of Nazareth. It was a home for orphans and old people. In its later years it was for old folk only. It closed in 2002 and the building was later converted to flats with the name of Derwent House.

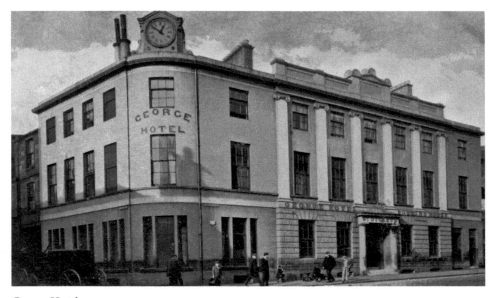

George Hotel

The George Hotel opened in 1824 and lasted nearly 100 years. It was used in 1843 when the Glasgow, Paisley, Kilmarnock and Ayr Railway opened the branch from Kilmarnock to Dalry and Glasgow. The opening of the railway was celebrated with a lunch at the George Hotel. The hotel was closed in 1920 and the building soon became Lind's shop. Part of the building became the George Cinema. Today the building is used by long-established local furniture shop Mason Murphy.

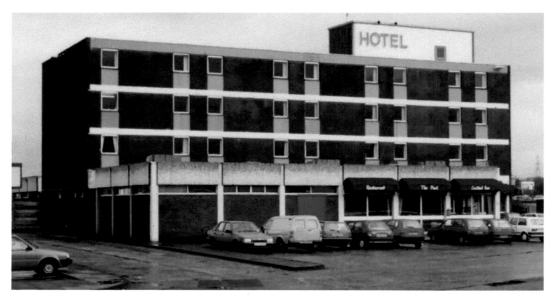

Howard Park Hotel

The Howard Park Hotel was opened at Glasgow Road, in 1975 on what at the time was the northern tip of Kilmarnock. For more than twenty-five years it was the largest and most significant hotel in Kilmarnock. The hotel was given a major refurbishment in 1988 but it closed in 2010 and after lying derelict for some time the building was demolished in 2014.

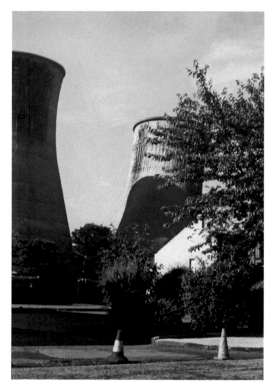

Cooling Towers

For a whole generation, one of the most prominent landmarks in Kilmarnock was the pair of massive cooling towers for the electric power station at Greenholm Street. One of them had been built in 1939 and the other in 1942. They were demolished by controlled explosions in 1976.

Decorative Gate

This decorative gate was on the multi-storey car park at the Foregate. The car park is scheduled to be demolished in 2023 and it is planned that the gate should be set aside for use in a future development.

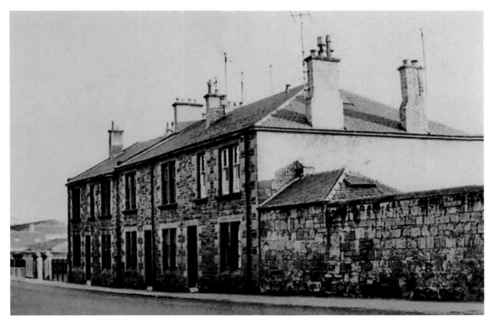

Tenement Buildings

In the late nineteenth and early twentieth century many streets in Kilmarnock had tenement buildings constructed. As time has gone on many of these tenement blocks have been replaced by more spacious houses. This block was in Bentinck Street.

Prefabs

In the years immediately after the Second World War, there was a desperate need for housing and more than 200 temporary homes – prefabs – were built in Kilmarnock. They were called prefabs because they were largely pre-fabricated off site. Some were later revamped and had brick cladding added. Many have now been demolished but a few of the prefab homes remain today.

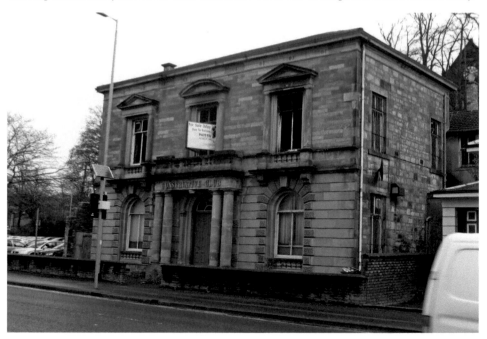

Conservative Club

The Kilmarnock branch of the Conservative and Unionist Association opened their Conservative Club premises in Sturrock Street in 1887. In 1980 the building was given Grade B listed status. But membership fell and the building was closed. By 2021 the building had been long abandoned and fire damaged and it was demolished.

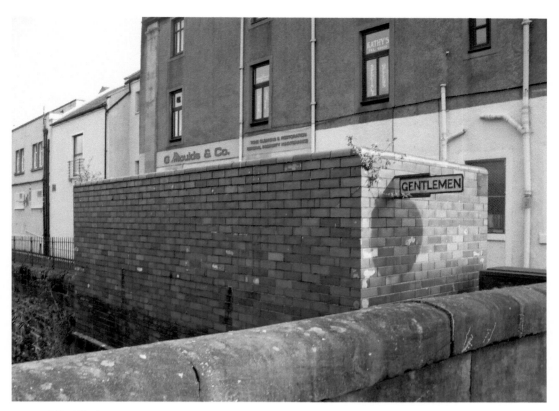

Toilet Block

In 2008 the old long-disused public toilet block at the Sandbed was demolished. It was only ever a urinal for gents and the produce went straight into the river. The building was simple and had no real roof, but it was built of distinctive glazed bricks which had probably been made locally.

6

Sport and Leisure

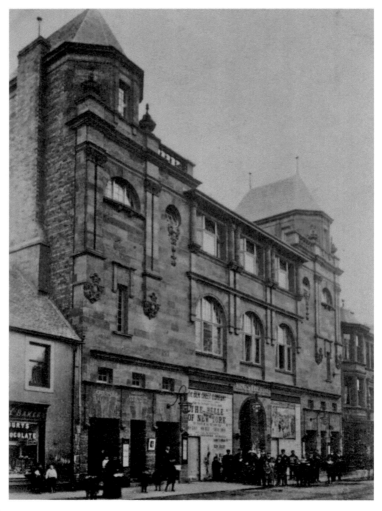

King's Theatre

The King's Theatre was opened in Titchfield Street in 1904. From the earliest days, films were shown and eventually the building became the ABC Cinema, the Regal then the Canon. It was closed in 1999 after the Odeon multiplex was opened at Queen's Drive. The building has been derelict since then.

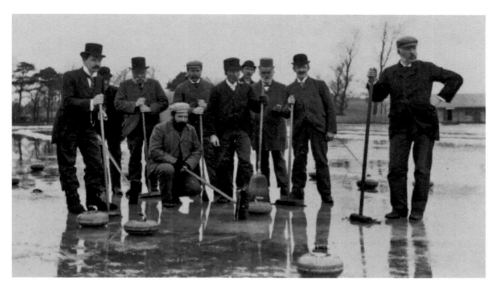

Curling

Curling is known to have been played in Kilmarnock as early as 1644. The winter of 1740 was a severe one. Artificial dams were created in the streets around Cross and the area was flooded so that the water would freeze and create an ice rink for curling. This allowed the game to be played for twenty-three consecutive days, not including Sundays, of course. Curling remains popular, but today games are played indoors.

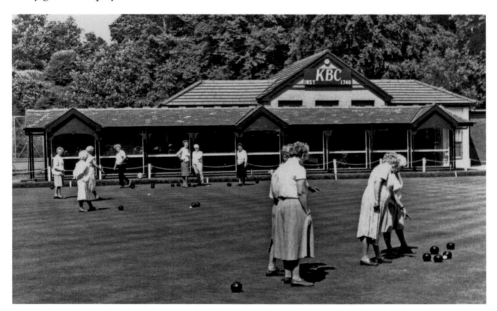

Kilmarnock Bowling Club

Kilmarnock Bowling Club was established in 1740 near the Cross. They moved to Mill Lane in 1824 but in 1826 the land was required for a church and they moved to a site off London Road. The club was the oldest bowling club in Scotland. The impact of Covid-19 meant the club could not hold events and it closed in November of 2021.

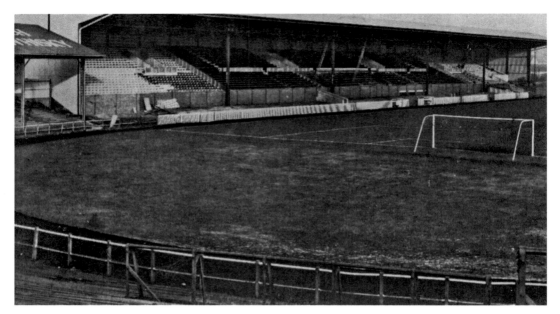

Old Stand at Rugby Park

This is the old stand at Rugby Park, the home of Kilmarnock Football Club, before rebuilding in 1961. Since then other stands have been built.

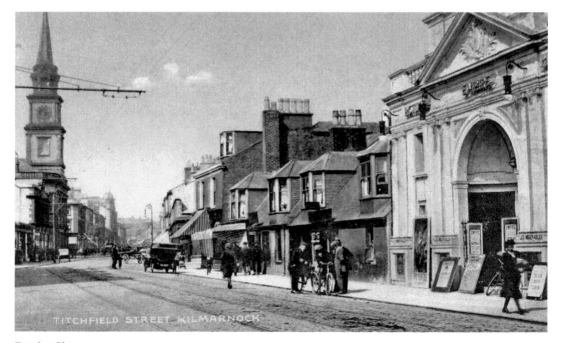

Empire Cinema

The building prominent in the foreground of this picture was the Empire Cinema. It was originally opened as the Empire Picture House in 1913. One endearing feature was the back row made of double seats, for those who liked a little intimacy in the cinema. The building was destroyed by fire in 1965.

Lauder Bridge

On 3 June 1905, a new suspension footbridge was opened over the Kilmarnock Water near the Dean Ford. So many people wanted to be among the first to cross it that the suspension cables snapped and the bridge collapsed into the river. The bridge was soon replaced. The new cast-iron suspension bridge with decorative end supports and wire rope was given C grade listed building status in 2002, but it and the adjacent ford were replaced by a new road and pedestrian bridge in 2015.

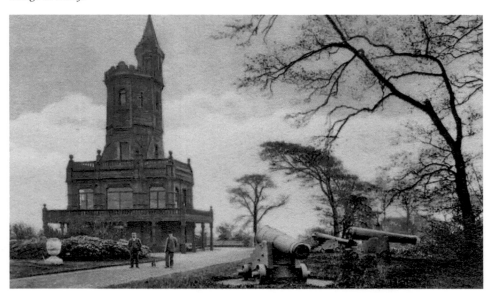

Burns Monument

The Burns Monument in the Kay Park was built in 1879 and quickly became an icon for the town. It was severely damaged by a fire in 2004. Plans to build a new centre round the remains of the monument were put in place. Today it is a centre for family and local history research and it also houses the office of the local registrar.

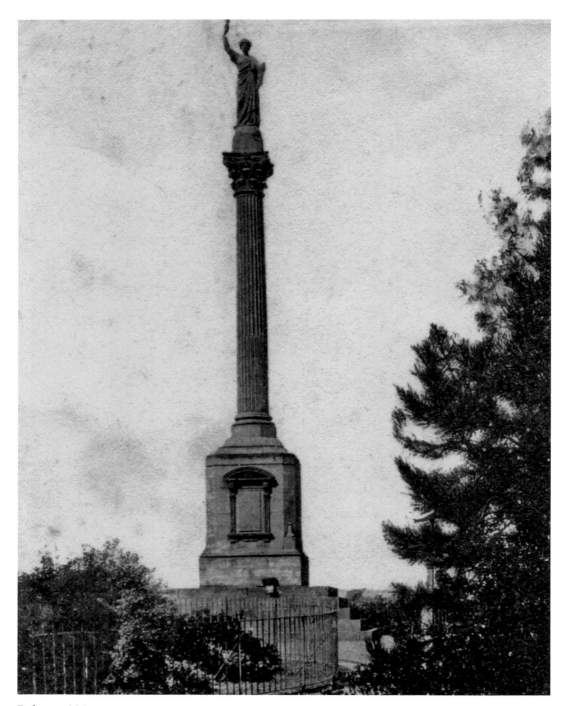

Reformers' Monument

Those who bravely stood up to the Establishment and campaigned for the right to vote are remembered in a monument in the Kay Park. The original Liberty statue on top of the pillar was destroyed in a storm in 1936 and has never been replaced.

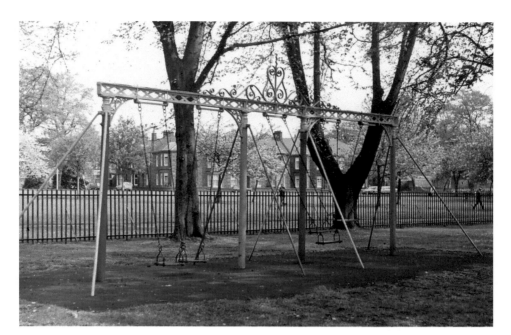

Decorative Swings

The decorative cast-iron frame for this set of swings was made by Wicksteed of Kettering and was in the Howard Park for many years before being replaced.

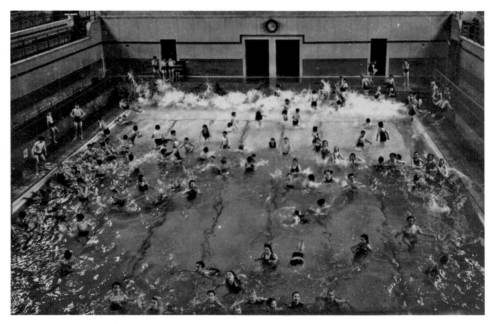

Swimming Pool

Kilmarnock's municipal swimming pool was opened in 1940 and had a unique feature in the form of a machine that could make waves that constantly changed their shape. It was very popular, but was discontinued when the pool was replaced by the Galleon Leisure Centre in 1987.

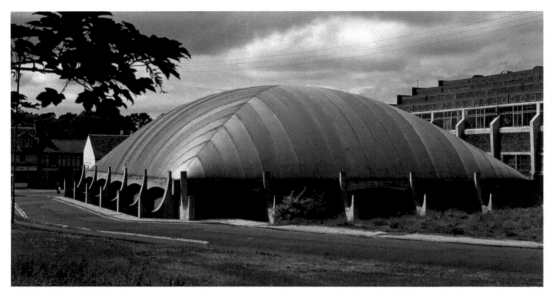

The Bubble

The Bubble was an annexe to the swimming pool and was kept up by air pressure. Like the swimming pool, the Bubble was replaced by the Galleon Leisure Centre.

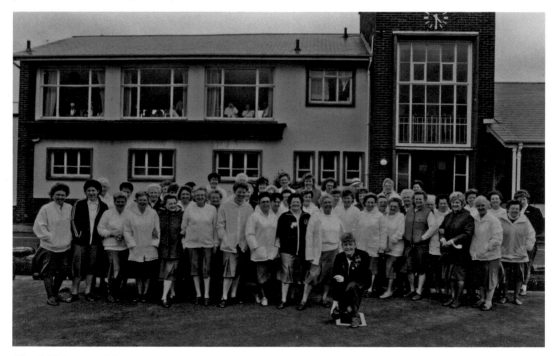

Glenfield Sports Club

Kilmarnock had many industries with big workforces. Most provided sports and recreational facilities for their workers and families. Glenfield and Kennedy had a sports pavilion and sports grounds at Queen's Drive. Employees could enjoy tennis, football, cricket and bowling.

Imperial Picture House

The Scotia Cinema opened in Union Street in 1920. It later became the Imperial and at a later date the Savoy. The building was converted to a dance hall in the 1950s.

7

Commerce

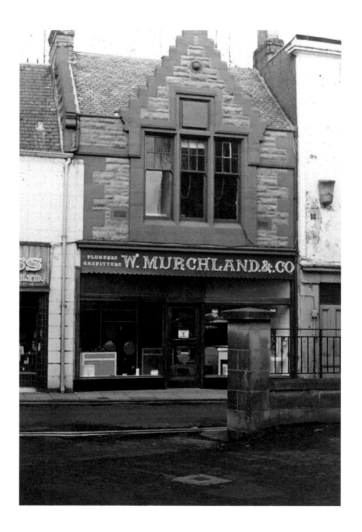

Murchland

In 1875 William Murchland established his business in Kilmarnock, covering the trades of plumber, slater, tinsmith and gasfitter. He also dealt with a wide variety of goods and services including those covering incandescent gas lighting, mechanical and electrical bells, telephones, heating and ventilation. In 1889 William Murchland patented the first milking machine. Over the years the business had various properties on Kilmarnock, including this distinctive one in Bank Street.

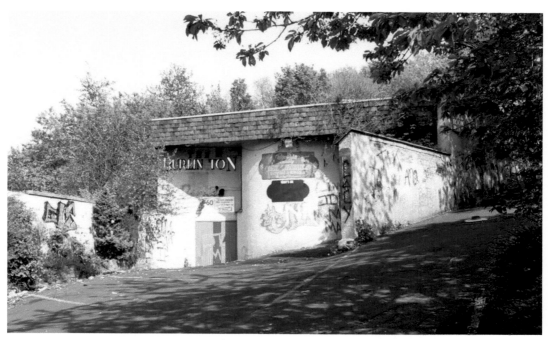

Burlington

The former Burlington Bertie's pub building at Braefoot was destroyed by fire in 2007. The building had been derelict for several years. Before becoming the Burlington Bertie's pub, it had been the Labour Party Social Club.

JOHN BOYLE,

Wholesale Drysalter, Oil, Colour and Varnish Merchant.

123 TO 127 KING STREET, KILMARNOCK.

Telephone No. 246. Established 1874.

Wholesale Agent for—

The Anglo American Oil Co., Ltd.

Lubricating and Burning Oils. Grischotti & Co., Ltd.

Vulcan Matches. John Oakley & Sons, Ltd., London.

Emery Cloth, Glass Paper, Garnet Paper, Etc.

To USERS OF MACHINERY OIL, Etc.,

Prompt attention given to enquiries for :

Engine Oil. Gas Engine Oil. Cylinder Oil.
Lubricating Oil. Special Lubricating Oil.

For Cycles, Hinges, Locks, Lawn Mowers, Sewing Machines, and all Domestic Purposes.

Special Quotations for the undernoted in Quantities

Acids	Ammonia.	Bees Wax.
Benzoline.	Black Lead.	Black Varnish.
Bleach.	Borax.	Brushes
Candles	Chamois Skins.	Chloride of Lime
Hall's Distemper.	Emery Cloth, Etc.	Glycerine.
Disinfectants.	Linseed.	Matches.
Metal Polish.	Methylated Spirit.	Oils (all varieties)
Paints (all varieties).	Red Lead.	Saltpetre.
Seeds.	Soap (all varieties).	Soda.
Sulphur.	Tartar.	Tartaric Acid
Twines	Turpentine.	Varnishes
Waste	White Lead.	Wick.

Boyle

John Boyle was a drysalter. His business was established in 1874 and he dealt with wholesale and retail. He was at No. 123 King Street, next door to King Street Church. The shop was demolished at the same time as the church.

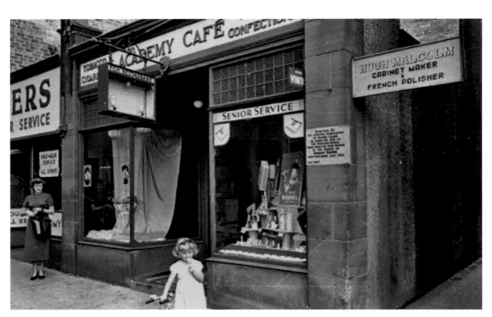

Academy Café

The Academy Café was in Waterloo Street in the 1950s and presumably took its name from Kilmarnock Academy. I wonder if anyone remembers going there.

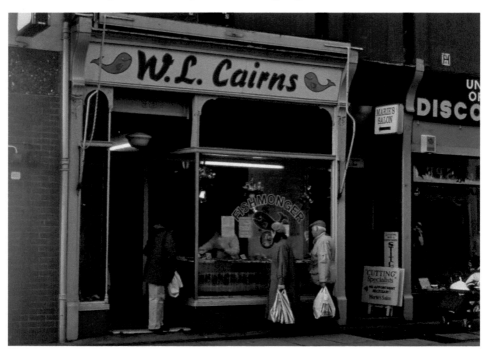

Cairns

William Cairns was a fishmonger with a shop in Cheapside Street until the 1970s. The 1957 Directory lists William Cairns shop at No. 29 Old Street, Riccarton.

Dark Horse

The Dark Horse pub and restaurant was opened at Glencairn Square in 1956 and was one of the first of its kind in the town, offering bar, restaurant and dance floor. It later became the Hunting Lodge, and is now trading as Maggie's. It took its original name from an earlier pub near the site. It had been the Glencairn Arms but was popularly known as The Dark Horse.

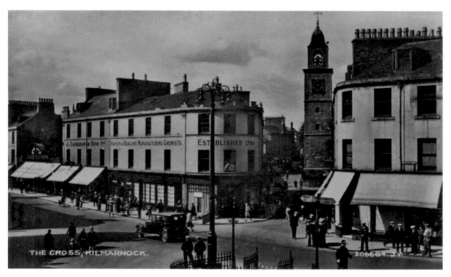

Cameron

John Cameron was a jeweller, watchmaker, clockmaker and silversmith who established his business in King Street in 1840. He was able to advertise that he was watchmaker to the Admiralty. Cameron's went through various transformations and changes of ownership and the last jeweller on this site was Goldsmith who closed the shop in 2022.

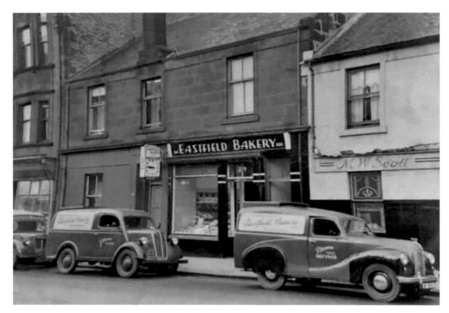

Eastfield Bakery

Eastfield Bakery was in High Glencairn Street with a shop on the street and a bakery behind. It is listed in the 1957 local directory. It was established in property once used by Gardner the baker. It later became Beattie's bakery.

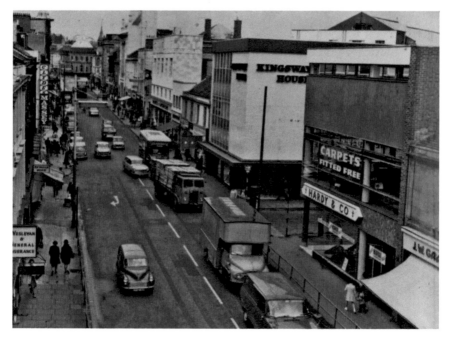

Kingsway House

Kingsway House was opened in King Street in the 1970s by the Co-op. The building has gone through various changes of ownership since then and some changes to the structure of the building.

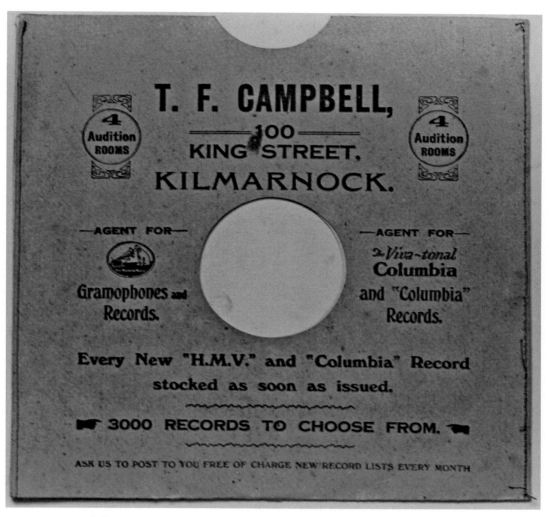

T. F. Campbell

Shopping began to change in the 1960s, though it wasn't quite recognised at the time what a big impact the new supermarkets and multi-nationals would have. T. F. Campbell was a typical local shop. It was not just a record shop; they provided toys, prams, bicycles and just about anything that the shop proprietor fancied selling. In 1960 T. F. Campbell was taken over by Ayrshire Wireless Services Ltd, but it continues to trade under the name of T. F. Campbell.

Tam o' Shanter

The Tam o' Shanter Arms was a popular pub in Waterloo Street, Kilmarnock, close to the site of John Wilson's printing works, where the first book of poems by Robert Burns was printed. On the front of the Tam o' Shanter building there was a heart-shaped stone dated 1761.

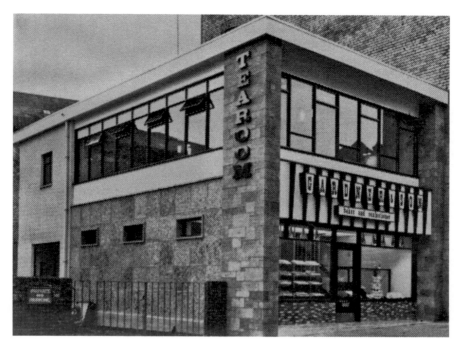

Gardner

Gardner the baker was a long-established local business. In the 1930s William A. Gardner was listed as a baker at No. 27 High Glencairn Street. In 1957 they were in Croft Street, seen here. This became a popular tearoom as well as a shop. The business also had a large bakery in the town.

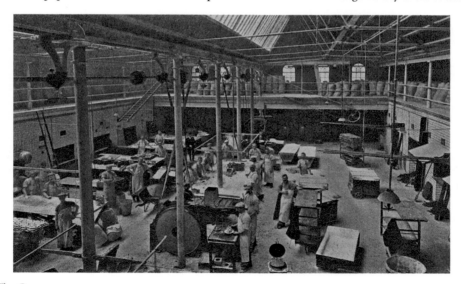

The Co-op

The Kilmarnock Equitable Co-operative Society was founded in 1860, drawing inspiration from the Fenwick weavers who founded the first Co-op in 1761. The business grew rapidly and soon had branches in every part of town and the surrounding villages. The picture shows the Co-op bakery in St Andrew Street. It supplied all the company's shops.

Flour Power

Donaldson of John Finnie Street described themselves as The Flower People. In the 1980s they were based in John Finnie Street. David Lauder started his baker's shop in King Street in 1869. It later included a restaurant and the shop sold all manner of foodstuff, including cakes, confectionery and his own brand of shortbread. When the shop was in John Finnie Street next door to Donaldson's their neighbours put a sign in their window saying, Donaldsons, the flower people. Lauders responded with a sign saying Lauders, the flour people.

Frasers

Lauders the Emporium was established in King Street 1864. In 1975 the owners decided on a national image and named it House of Fraser. The shop was closed in 1988 and the property was split into three separate shops.

Auld Hoose

The Auld Hoose was a traditional pub that was established in Titchfield Street in 1883. In the early twenty-first century it had several names and now trades as a top-of-the-range diner called The Longhouse.

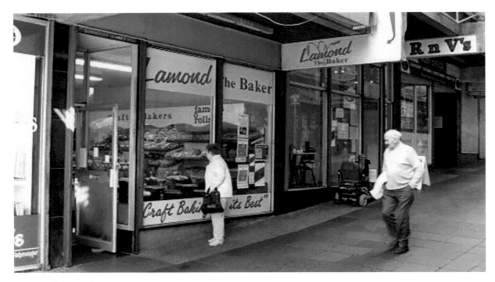

Lamond the Baker

The local family firm of Lamond the baker was established in 1914. The branch in the Foregate business was taken over by Brownings in 2009.

Artful Dodger

The Artful Dodger was a restaurant and pub in the former Borland's grain mill in St Marnock Place from around 1992. Today the property is La Dragon, a popular Chinese restaurant.

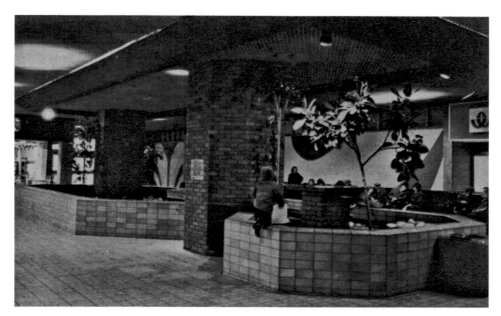

Burns Precinct

When a new shopping mall was opened in 1976 it was given the name Burns Precinct, but there was so much popular opposition to the use of that term that the name was changed to the Burns Mall. Several changes have been made inside including the removal of the water feature seen here.

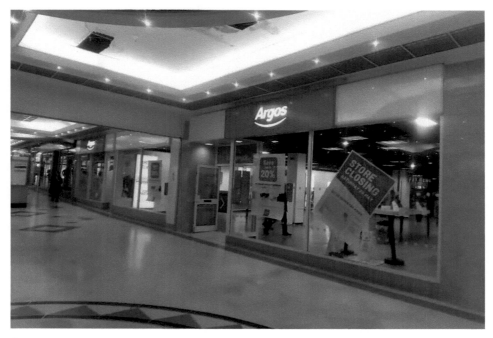

Argos

For many years one of the anchor stores in the Burns Mall was Argos the catalogue shop, but with difficult trading conditions, the shop was closed in 2022. Note that Woolworths is also gone.

Top of the Hops

The Top of the Hops shop in the Foregate opened in 2015 selling all sorts of home-brewing gear and ingredients and a good selection of bottled beers. It closed in 2016 after a little more than a year in business.

Mothercare

After King Street Church, on the corner of King Street and Saint Marnock Street, was demolished a parade of shops was built on the site. It became known as the Mothercare block because that retailer had a double unit right on the corner. They closed the Kilmarnock branch in 2014. The block was demolished in 2021.

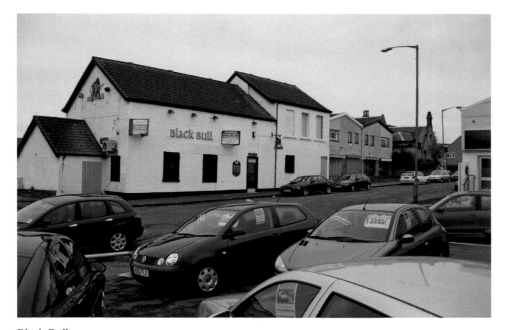

Black Bull

The building that had long housed the Black Bull pub in Campbell Place in Riccarton was demolished in December of 2008. The well-known Kilmarnock landmark was taken down to make way for a new purpose-built veterinary practice.

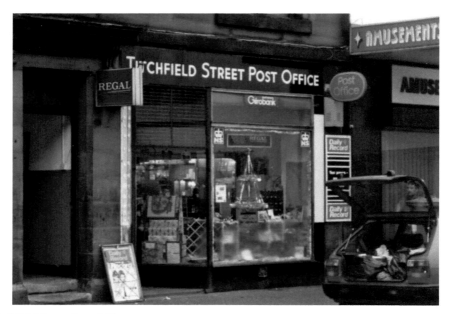

Titchfield Street Post Office

The Titchfield Street sub-post office was opened on 1 October 1886 with money order and savings bank status. It was the oldest town sub-office in Kilmarnock when it was closed in January 2004.

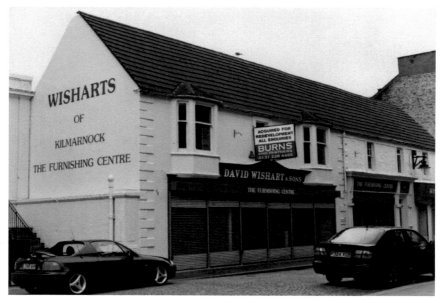

Wishart

The David Wishart furniture shop in Bank Street started trading around 1875. After around 120 years of trading the business was closed and Wilson's, another furniture shop, opened in the same group of buildings. Wilson's closed in 2000 and the building became the First Edition, a popular bar and diner.

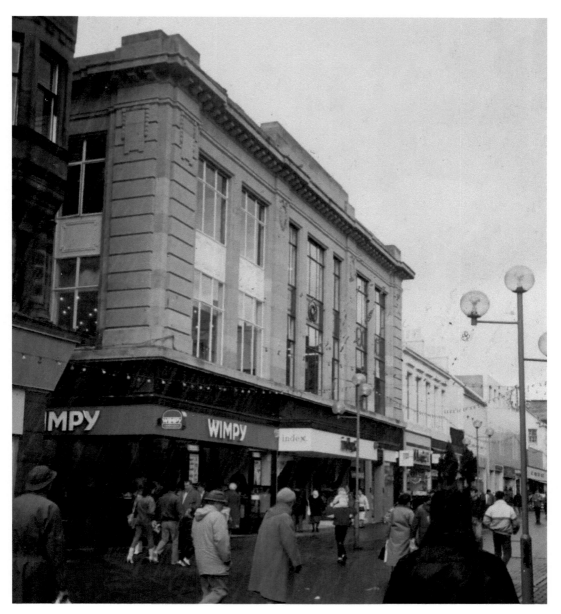

Wimpy

The Wimpy burger chain had a branch in King Street in Kilmarnock in the former Lauder's Emporium building. Although that branch later closed, there is still a Wimpy inside The Garage ten-pin bowling and leisure building.

White Tile Building

The so-called White Tile Building was constructed on the site of the Lamont the Tailor building which was destroyed by fire in 1967. Various shops occupied the building over the years. The building is empty and faces an uncertain future.

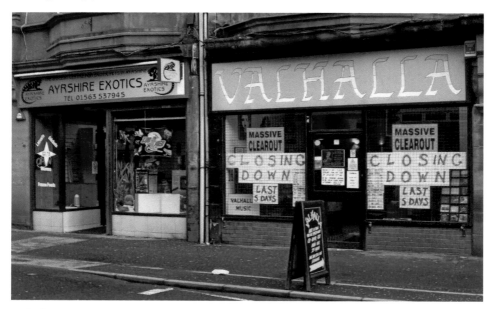

Valhalla

Valhalla Records was closed in 2011. Dave Ross opened the independent record shop in Kilmarnock in 1993, but changing patterns in the way music was being purchased made the shop uneconomic.

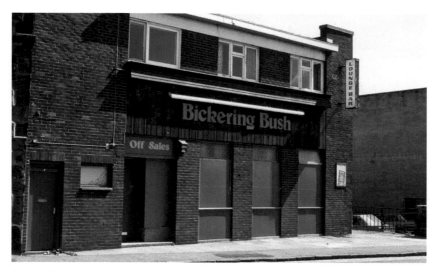

Bickering Bush

Local tradition says that when he was a young man growing up around Ellerslie, Riccarton and Kilmarnock, Sir William Wallace was fishing in the River Irvine when he was accosted by English soldiers who demanded the fish he had caught. This led to a confrontation which left three of the invaders dead. The Bickering Bush was the name of a thorn bush which was said to have marked the site of the conflict. In later years a pub in Riccarton used the name. A plaque at Riccarton Bridge tells the legend of the bush.

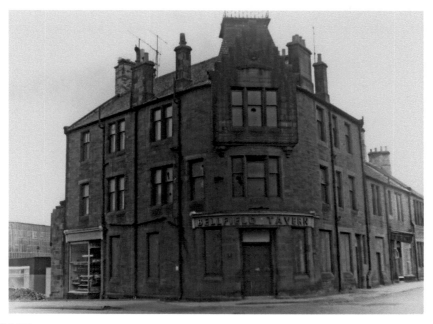

Bellfield Tavern

Some pubs were lost in the 1970s redevelopment programmes. They included the original one, which was replaced by the New Bellfield Tavern close to the original site. That pub has now also closed.

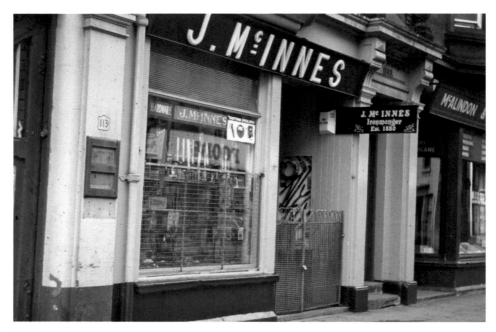

McInnes

The local firm of John McInnes, ironmonger and tools shop, was established in 1880. In 1930 the business was run by James McInnes and was based in the King's Theatre Building. In 1957 the shop was in Titchfield Street. The business was closed in 2022.

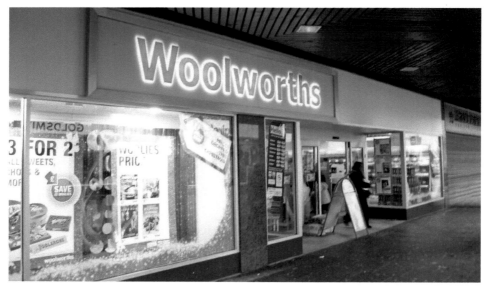

Woolworths

The national retailer F. W. Woolworth opened a 3*d* and 6*d* shop at the corner of King Street and Market Lane in Kilmarnock in 1925. For a whole generation, Woolworths became a favourite shop to visit. The store moved into a large unit in the Burns Shopping Centre in the 1970s but was closed in 2009.

Land it wi' McCririck's Fishing Tackle.

They may be shy jist for a while
But dinna let them rest ;
When once they bite you've got
the gear—
McCririck's Tackle is the best.

There's nane better
Ye canna get away frae't !

Hand Loaded
Cartridges
our speciality.

Repairs to Guns and Fishing Rods.
WE ARE ALSO TAXIDERMISTS

McCririck & Sons

Gun, Rifle, and Fishing Tackle Makers,
6 John Finnie Street, Kilmarnock.

PHONE	EST'D	TELEGRAMS:
577	1800	" McCririck, Kilmarnock."

McCririck

The McCririck business was established in 1800 by a gunsmith and was run by the McCririck family until 1971. In 1900 the business was in Bank Street and the proprietor was William McCririck. At that time he was the only gun maker listed in the directory. It closed in 1998, by which time it sold a wide variety of hunting and fishing equipment. At that time McCriricks was in John Finnie Street.

SAVE ON CHRISTMAS SHOPPING

No Deposit
No Enquiries
No References

GIFTS
FOR THE
HOME

for every
room

for every
budget

Hay's
Complete House Furnishers

AYR:
250 High St

Kilmarnock:
5–13 Duke St

Better buy from HAYS
than wish you HAD

Where you EXPECT the
BEST and GET IT

Hay's

Kilmarnock's long-established Richardson furniture retail business was taken over by Hay's of Ayr in 1936. The business was in Duke Street until final closure at the start of the 1970s.